THE
STROUDWATER
AND
THAMES & SEVERN
CANALS

From Old Photographs

THE
STROUDWATER
AND
THAMES & SEVERN
CANALS
From Old Photographs

EDWIN CUSS & MIKE MILLS

AMBERLEY

First published by Alan Sutton Publishing Limited, 1988
This edition published 2010

Copyright © Edwin Cuss and Mike Mills 2010

Amberley Publishing
Cirencester Road, Chalford,
Stroud, Gloucestershire, GL6 8PE

British Library Cataloguing in Publication Data.
A catalogue record for this book is available from the British Library.

ISBN 978-1-84868-786-8

Typesetting and origination by Amberley Publishing
Printed in Great Britain

Contents

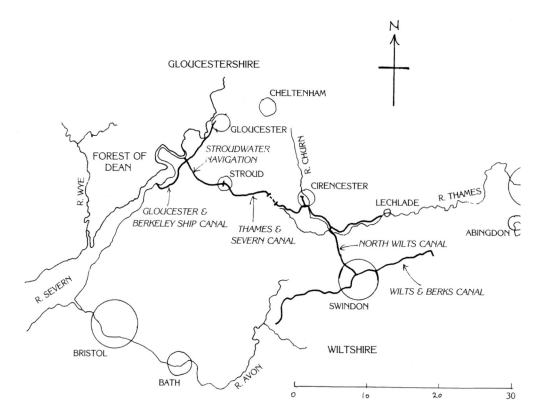

Foreword

Since the publication of the original book in 1988 Stanley Gardiner passed away in 1997.

Starting in the late 1960s and onwards until his death, Stanley Gardiner and his friends Lionel Padin and Mike Mills, who were all born and bred Chalfordians, became aware that the village was changing dramatically and they endeavoured to gather together information and photographs about Chalford before it was too late. Inevitably this search expanded into the whole surrounding area. A huge amount of material was collected, collated and photographed and this collection led to the publication of many books on local subjects and Stanley Gardiner's untimely death was a great loss in this respect.

Edwin Cuss and Stanley Gardiner collaborated on the publication of the original book in 1988, but in order to reprint this book, it was necessary to move with the times and the rapidly changing technology of publishing; therefore Edwin Cuss and Mike Mills with the blessing of Mrs Nancy Gardiner have been able to search out most of the original photographs for digital scanning compared to the photographic process used in 1988.

The captions to the pictures and the introduction have also been altered where necessary to cope with the passage of more than twenty years. We were unable to trace a very small number of the pictures and a few have been changed, but basically this book remains a reprint of the original.

January 2010

Introduction

Both the Stroudwater Navigation and the Thames & Severn Canal evolved towards the end of the eighteenth century during the years of the Industrial Revolution and the associated canal 'mania'. They were the final results of various suggestions and schemes made over many decades to try and improve transport in their respective areas, and although they were joined together, each canal was built for its own reasons.

The developing woollen mills in the River Frome valley found themselves less able to compete for business due to poor communications and transport, and this led local businessmen to seek a solution to their problems. The Stroudwater Navigation was therefore constructed from the River Severn at Framilode to Wallbridge at Stroud. It opened in 1779 and was 8¼ miles long with twelve locks, which were able to accommodate the trows, the main trading vessels operating on the River Severn at that time. The construction costs of the canal were all raised locally and it operated very successfully with few problems.

In 1827 it was linked to the national canal system when the Gloucester and Berkeley Ship Canal was built to circumnavigate the difficult parts of the River Severn below Gloucester. Dereliction came in the 1940s and closure became inevitable in 1953, but the Company of Proprietors of the Stroudwater Navigation has remained in existence. Small sections of the canal have been restored over the years since the Stroudwater Canal Society was formed in 1972. But now under the guidance of the Cotswold Canals Trust, the successor to the original society, long sections are undergoing large-scale restoration. Phase 1A of the restoration programme includes the section from the Ocean at Stonehouse through to Brimscombe Port, and in years to come other phases of restoration will follow.

The Thames & Severn Canal was born out of a national desire by various businessmen to form a link between the River Thames and the River Severn when it was hoped to promote a through trade route between London and the West. It opened in 1789 and was 28¼ miles long with forty-two locks. It joined the River Thames at Inglesham with the basin of the Stroudwater Navigation at Wallbridge in Stroud, crossing the Watershed of the Cotswold Hills by means of a grand canal tunnel. The construction costs were eventually around £250,000, some of which was raised locally, but most nationally. It was built to accommodate the long Thames barges on its eastern stretches and the wide Severn trows on its western stretches, but as these two types of vessels were of different dimensions, through traffic was only accomplished by the use of a large transhipment port at Brimscombe. The canal experienced operating problems almost straight away and over many years water supplies and constructional defects had to be remedied. Throughout the life of the canal, these problems were never completely solved. In 1819 a link was formed by the North Wilts Canal from Latton on the Thames & Severn Canal to the Wilts and Berks Canal at Swindon. In later years traffic on the Thames & Severn Canal tended to use this link to get access

to the River Thames at Abingdon, thereby bypassing the upper reaches of the River Thames where low water difficulties often impeded traffic for long periods in the summer months. The canal was fairly successful for around fifty years until the railways came into the area in 1841, but from then on income from tolls began to decrease and the last dividend was paid in 1864. Two attempts at restoration in 1896 and 1902 were made to encourage traffic back onto the canal but commercial traffic across the summit level ceased in 1912 with closure and abandonment following in two phases in 1927 and 1933. As with the Stroudwater Navigation, sections of the canal are also being actively restored by the Cotswold Canals Trust, and one of their long-term aims remains 'to achieve restoration of the Cotswold Canals as a navigable route from Saul Junction to the River Thames'. In many sections the towpath has been cleared for walking and undergrowth has been cleared from the canal bed.

Readers will find that we have included a few photographs of the River Severn, the Gloucester and Berkeley Ship Canal and the River Thames merely because the fortunes of all waterways were also very dependent on their other links into the national waterways system. There is neither the space nor the need in this small volume to go into the many historical details of these two canals but a good deal of information is available in five excellent books on the subjects which must remain compulsory reading for anyone interested in them:

The Stroudwater Canal by Michael Handford, Alan Sutton Publishing 1979.
The Stroudwater Navigation by Joan Tucker, Tempus Publishing 2003.
The Stroudwater and Thames & Severn Canals Towpath Guide by Michael Handford and David Viner, Alan Sutton Publishing 1984 and 1988.
The Thames & Severn Canal by Humphrey Household, Alan Sutton Publishing 1969, 1983 and new edition Amberley Publishing 2009.
The Thames & Severn Canal History and Guide by David Viner, Tempus Publishing 2002.

Many of the photographs used in this book have never been published before and they have come from many sources, such as local and national professional photographers and even family albums where probably only a box camera was used. We cannot hope to show, and we have made no attempt to show, all the features along the two canals as these are too many and too varied. As with most canals there are varying designs of brick, stone and iron bridges, locks of various designs and dimensions, small attractive round and square lengthmens' cottages, large and small wharves, warehouses with accommodation for agents and a tunnel which was the longest in existence at the time of construction. Our photographic collections, from which this selection has been made, have evolved over many years and we hope that what is shown will evoke memories in those people that can still remember the two canals, and will encourage others to get out and about to explore the canals as they are today. The newly restored sections of canal look very similar to the old views shown in the book and it is to be hoped that the Cotswold Canals Trust will eventually succeed in its intended aim of restoring the navigation between the two rivers, so that in years to come we shall once again see boats operating through these waterways.

Our grateful thanks go to all those who have loaned material used in this book and provided so much detail relating to it. Our special thanks go to the late Ray Smart, Fred Hammond, Lionel Padin and Duncan Young for allowing us to draw on their memories, and to Brian Hillsdon and Tony Langford for details relating to the Brimscombe Boatyard and its products.

The bicentenary of the opening of the Thames & Severn Canal fell on 19 November 1989, so how better to conclude this introduction than with the report published in the *Morning Post* of 27 November 1789 which referred to that opening:

On Thursday last was effected the greatest object of internal Navigation in this kingdom. The Severn was united to the Thames by an intermediate Canal, ascending by Stroud, through the Vale of Chalford to the height of 343 feet, by 40 locks: there entering a tunnel through the hill of Saperton for the length of two miles and three furlongs, and descending by 27 locks it joined the Thames near Lechlade. A boat, with union flag on her mast head, passed laden for the first time to St John's Bridge below Lechlade, in the presence of great numbers of people who were assembled on the occasion: and who answered a salute of twelve pieces of cannon from Buscot Park, by loud huzzas. A dinner was given at five of the principle Inns at Lechlade, and the day ended with ringing of bells, a bonfire and a ball. With respect to the internal commerce of the kingdom, and the security of communication in time of war, this junction of the Thames and Severn must be attended with the most beneficial consequences.

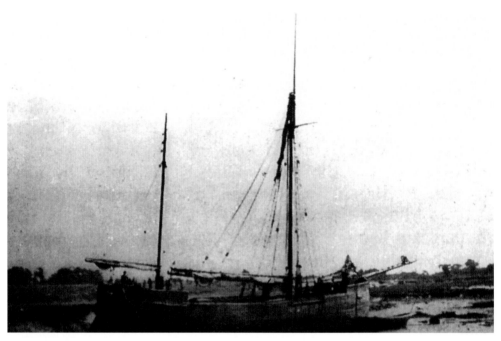

CLEVEDON, 1934. The trow *Palace* unloading stone for the sea wall. The *Palace* was built at the Bourne Boatyard (see page 72 and 73) in 1827.

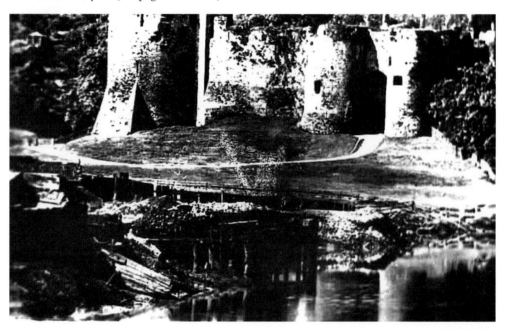

CHEPSTOW WHARF, *c.* 1905. Barges belonging to canal carriers in the Stroud valley often loaded stone at Chepstow Wharf for conveyance to wharves in the Stroud area. This enlargement of a part of the castle shows the old wharf with what looks like piles of stone awaiting shipment. Note the ghost image of the wooden wharf crane unsuccessfully eliminated by the photographer.

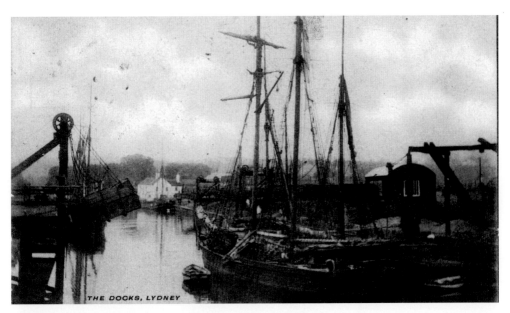

LYDNEY DOCKS, *c.* 1900.

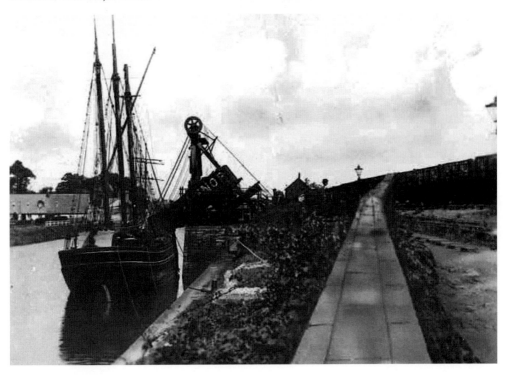

LYDNEY DOCKS, 1950. Two views of Lydney Docks half a century apart. The upper picture shows trows alongside the wharf with a wooden crane on the extreme right, whilst on the left is a truck-tipping mechanism. The lower picture shows such a mechanism in use, transferring coal into a boat. (GCRO)

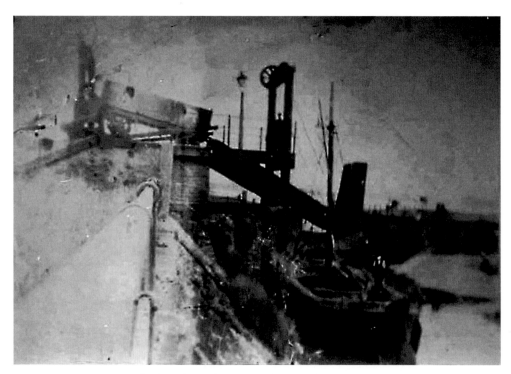

BULLO PILL, *c.* 1900. The boat being loaded at the tip is the *Finis*. We quote the comments of Mr Harry Trigg who loaned the original photograph: 'She was the last barge to trade out of Bullo and was put in the bank at Arlingham Passage in 1929 where remains of her can be seen today. She was often traded to Brimscombe and Dudbridge; also, after the First World War, to Cadbury's at Frampton via Framilode and Saul Junction. Sometimes she went on down the Gloucester and Sharpness Canal and loaded Forest coal, that came over the bridge at a tip in the old dock at Sharpness, for Cadbury's. She was not a true trow but a double-ender like the Brimscombe craft.' Mr Trigg's grandfather was the skipper and latterly the owner.

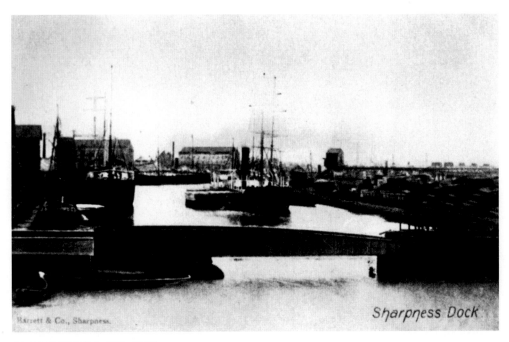

SHARPNESS DOCKS, 1907.

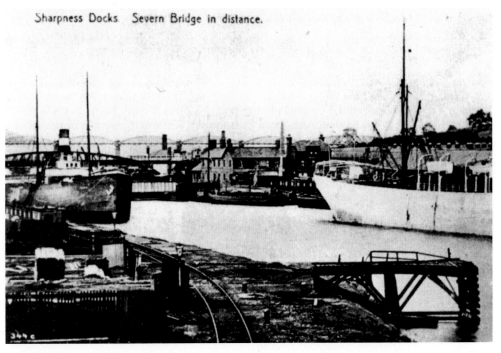

SHARPNESS DOCKS, 1930s. Two opposing views of the docks at the southern end of the Gloucester to Sharpness Canal, showing both sail and steam. Trows working between Stroud and the Severn estuary ports would have used this southern entrance to the canal.

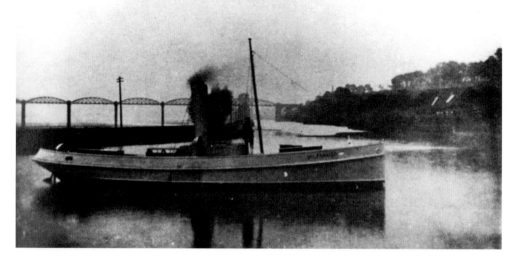

SHARPNESS, 1908/9. The steam tug *Valparaiso*, built by Abdela & Mitchell of Brimscombe for an overseas customer (see page 55), by the docks entrance. The Severn Railway Bridge is in the background. The tug may well have travelled under its own power from Saul, and possibly even from Brimscombe, for transhipment at Sharpness.

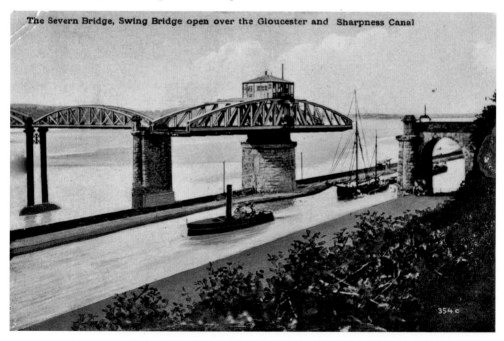

SHARPNESS, c. 1910. The swing portion of the Severn Railway Bridge open to allow the passage of a trow and barges under tow along the canal.

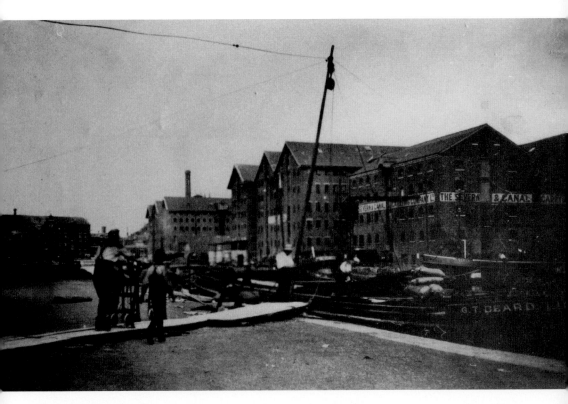

GLOUCESTER DOCKS, 20 August 1915. Unloading sacks from a lighter using sack trucks. Presumably the board walkway made a smoother ride for the truck.

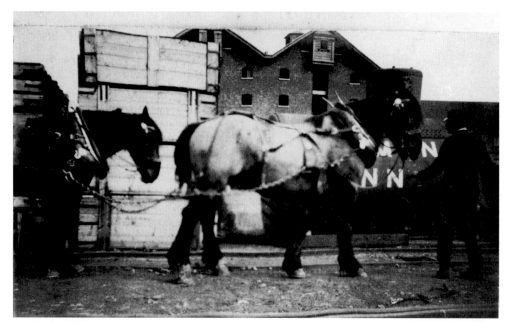

GLOUCESTER DOCKS, 20 August 1915. Another view showing a team of horses used to haul trucks and wagons.

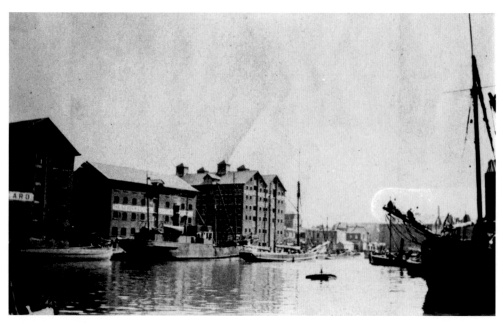

GLOUCESTER DOCKS, 4 August 1911. A busy scene with a variety of sailing ships and steam craft.

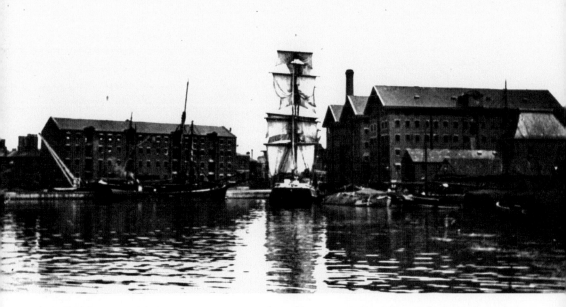

GLOUCESTER DOCKS, 30 August 1911. A sailing ship just arriving. It was only in recent years that such an expanse of sail could once more be seen in the docks!

Gloster
Feby 26th

Dear Sir

I write to inform you that we are lodding for back Home and thought of loading today and clearing the Junction but a Telegram come for a lot of trucks and stopped us Adams's have not loaded anything yet nor no likelihoods I did not know what to do for the best so I thought that I had better have this we shall have as much has we can bring we shall finish in the morning at Nicks and come to Ebley if all his well they have got a full load for Mr Harper here and I have promised to come back and fetch it without you have got anything else for us better There will be another half load ready at Price's for gardiner and shaile and we shall leave abo five tons here for Ebley I promised Price's that you wou have a Boat there on Tuesday we have got some in for Sm and Slate for Drew and for Wall and Hoo and for Webb and Harper.

I Remain you Truly W. Pearce

BARGEMASTER'S LETTER, *c.* 1885. Walter Pearce, a Chalfordian, was employed by James Smart of Chalford (see page 79), Coal Merchant and Canal Carrier. As can be seen from this letter, a variety of goods would be carried: timber from Nick's & Price's for Harper of Cainscross, Gardiner & Shaylor of Brimscombe, and Smith of Chalford, and slate for Drew of Chalford and Wall & Hook of Brimscombe.

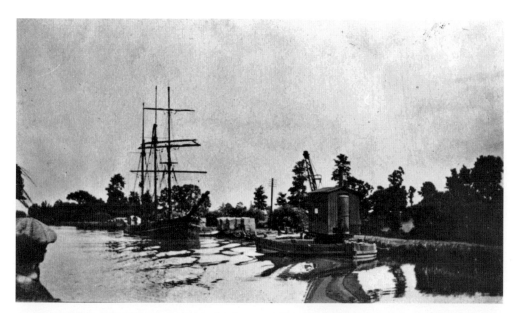

GLOUCESTER–BERKELEY CANAL, 30 August 1911. Probably a photograph taken from one of the passenger-carrying ships *Wave* or *Lapwing* which plied daily between Gloucester and Sharpness early last century. The location is not known but both the three-master and the steam-crane boat appear to be moored. Was the latter a dredger?

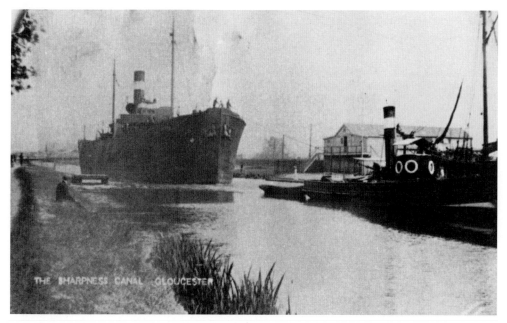

GLOUCESTER–BERKELEY CANAL, 1907. The steam tug *Mayflower* is shown towing a tramp steamer. She was built in 1861 by Stothert & Marten at Hotwells, Bristol, and worked on the Gloucester–Berkeley Canal for over 100 years. She is the world's oldest tug and also the oldest Bristol-built ship afloat. She is now preserved at the Bristol Industrial Museum.

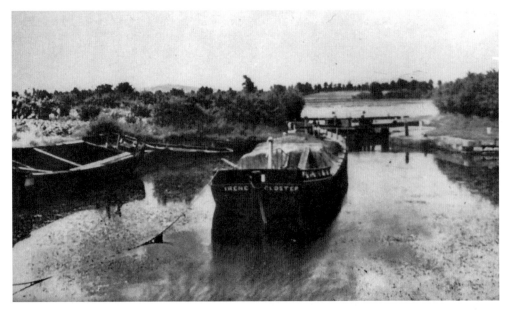

FRAMILODE BASIN, *c.* 1900. The trow *Irene* of Gloucester is seen here loaded and moored in Framilode Basin probably waiting for the right conditions in order to pass through the lock into the River Severn. The barge on the left appears to be partly beached, and from the appearance of the mooring rope, there seems to be a lot of weed in the basin. It can be inferred that by this time most commercial traffic out of the Stroudwater Canal was using the Gloucester–Berkeley Canal. (GCRO)

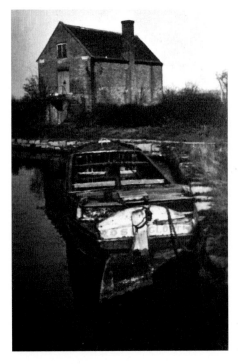

FRAMILODE BASIN, 1938. Another Gloucester boat, the *Rose*, moored at the wharf which shows considerable dereliction.

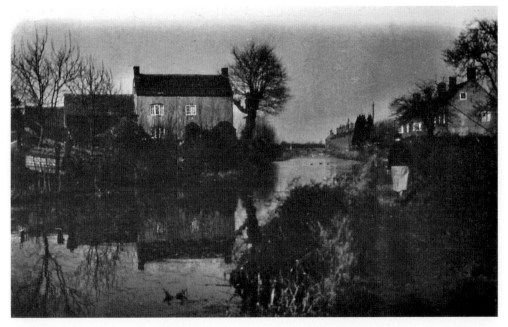

FRAMILODE, 1938. A partially disused stretch of the canal looking west.

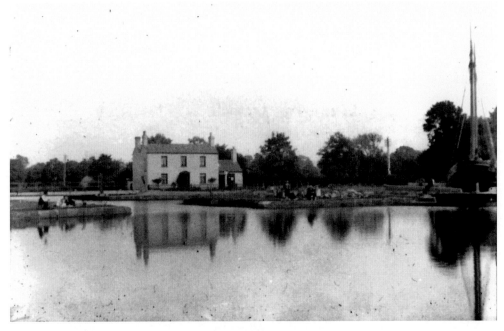

SAUL JUNCTION, *c.* 1910. A view taken across the mooring basin of the Gloucester–Berkeley Canal towards the Junction House. Left of the house is a swing bridge across the Berkeley Canal, and right of the house is the swing bridge across the Stroudwater Canal. The trow, extreme right, is in the dry dock across the corner of the two canals.

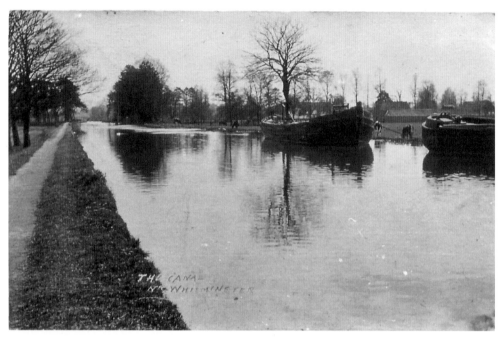

NEAR WHITMINSTER, *c.* 1920. The view along the canal towards Walk Bridge.

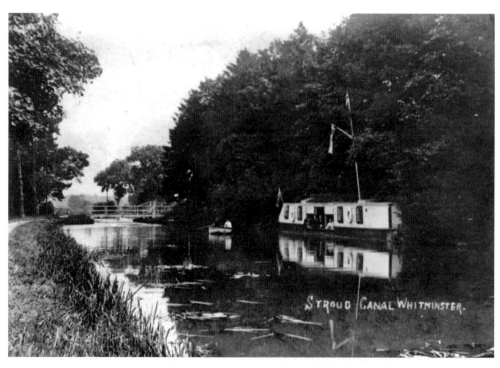

WHITMINSTER, 1909. A canal boat moored just west of the swing bridge.

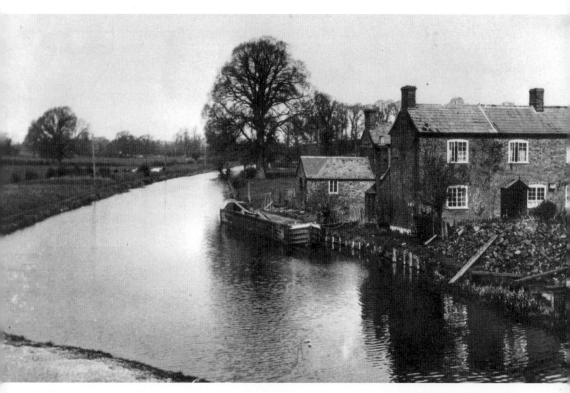

WHITMINSTER WHARF, *c.* 1930. A view of the wharf from the Bristol Road Bridge. This wharf was the first temporary limit of navigation during the building of the canal and might perhaps be better called the Bristol Road Wharf. The wharf appears to be well stocked with coal at this easy access point for onward delivery by road.

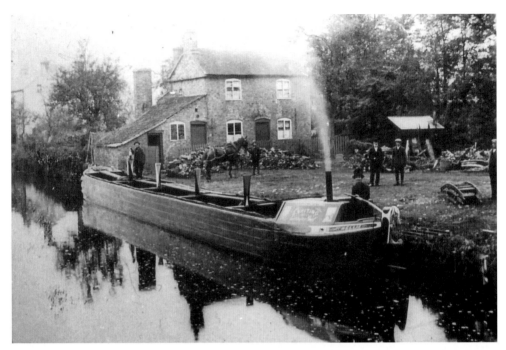

EASTINGTON WHARF, *c.* 1900. This wharf, just west of Pike Bridge and Lock, was sandwiched between the canal and the turnpike road. It was also known as Chippenham Platt Wharf and was an eastern extension of the maintenance depot for the canal. Whiting's barge *Nellie* is moored alongside with Mrs Chandler at the tiller and Mr Chandler on the walkway. The barge owner, Mr Whiting, is the white-bearded man on the wharf. Upside-down on the wharf, at right centre, is a two-man coal hog used to unload coal, etc., from a barge (see page 63).

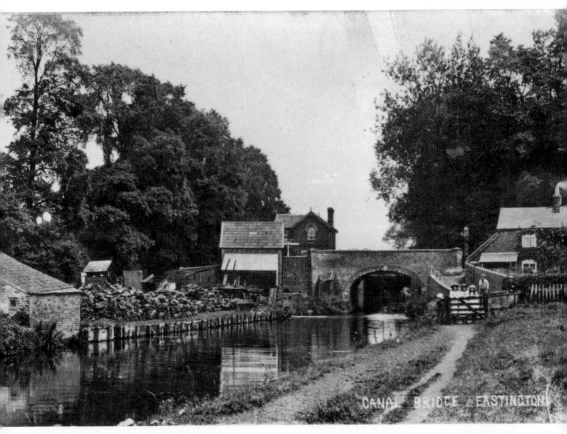

PIKE BRIDGE, EASTINGTON, *c.* 1910. Pike Lock can be seen through the bridge with the lock house left over the bridge. This bridge was replaced by a more ornate structure in the 1920s which remained until the roads were constructed for access to the M5 motorway. Note the well-used Eastington coal wharf on the left. Pike Lock is the third lock of the series of five which raised the canal out of the Severn Plain.

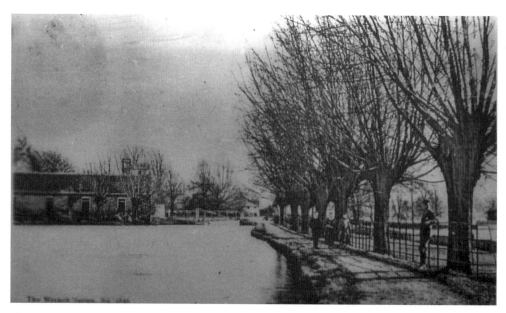

THE OCEAN, *c.* 1910. After passing under the Bristol–Gloucester railway, the canal widened into a considerable basin called the Ocean, where there was a small boat-repair yard. In the centre of this picture can be seen Stonehouse Court Bridge or Ocean Swing Bridge. The building on the left is an outbuilding of Stonehouse Court Farm.

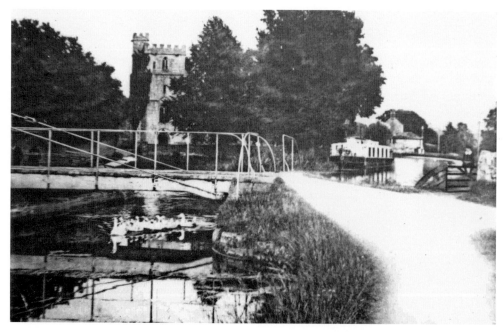

OCEAN BRIDGE, *c.* 1910. The iron swing bridge with St Cyr's Church tower in the background. Beyond the bridge is the company's work boat and in the distance is Nutshell Bridge Cottage. Note the family of swans passing under the bridge.

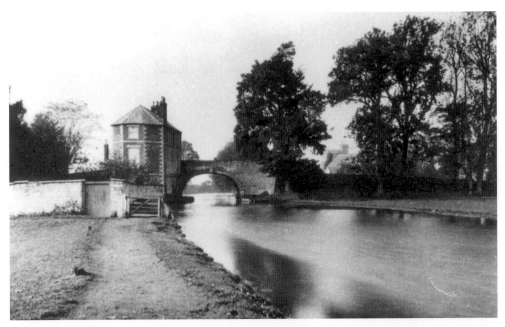

NUTSHELL BRIDGE, *c.* 1915. The bridge and cottage from the east. Through the trees to the right, the tower of St Cyr's Church is visible. Michael Handford suggests that the cottage may have been built as a 'look-out house' by the company but, as the bridge gave access for a private road to Stonehouse Lower Mills, was it built as a 'gatehouse' to the mills?

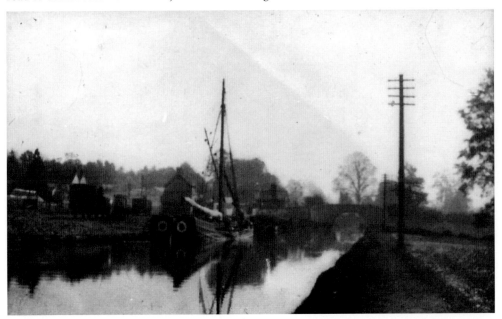

STONEHOUSE WHARF, 1911. A trow is moored at the wharf which is common to both the canal and the Midland Railway. There appears to be another boat beyond the Stonehouse Bridge.

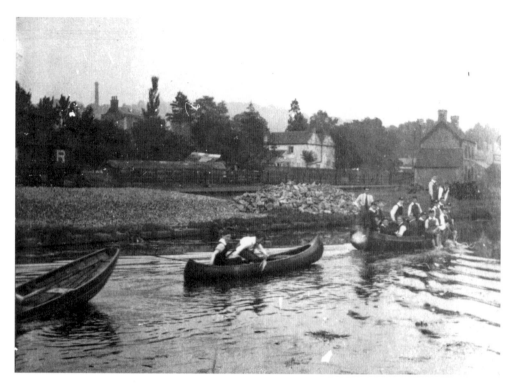

STONEHOUSE WHARF, *c.* 1915. Canoes from Wycliffe College under tow alongside the wharf.

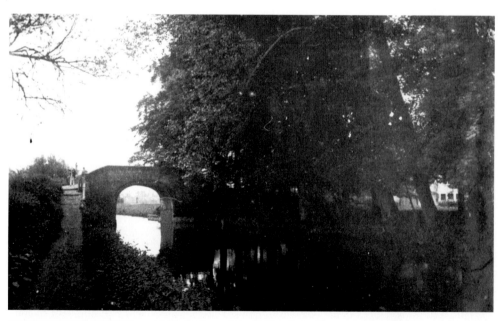

STONEHOUSE BRIDGE, *c.* 1915. A view of the bridge from the east with a portion of the wharf visible through the arch. On the right, the rear of the Ship Inn is visible through the trees.

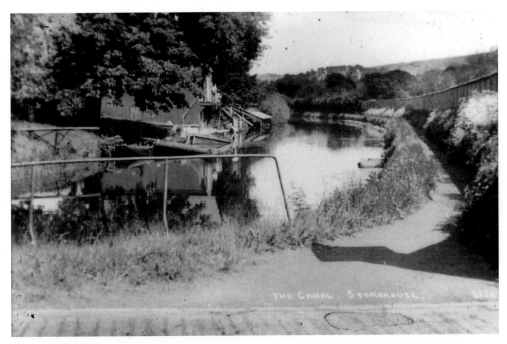

WYCLIFFE COLLEGE BOATHOUSE, 1930s.

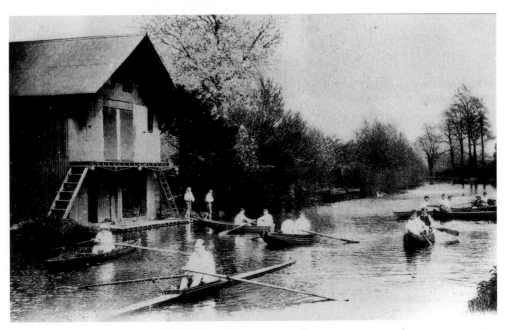

WYCLIFFE COLLEGE BOATHOUSE, *c.* 1915. The boathouse stood east of the swing bridge, which provided access over the canal to Stonehouse Upper Mills, and was just across the road and railway from the college grounds. After the Second World War and the closure of the canal to commercial traffic, the college boating activities moved to the Junction at Saul.

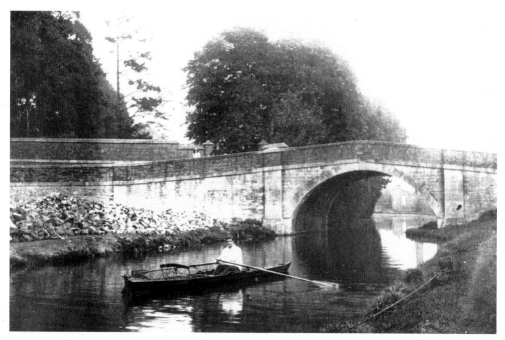

RYEFORD BRIDGE, *c.* 1915. This photo shows a pile of coal on Ryeford Wharf and an aspiring 'Blue' from Wycliffe College resting on his oars.

RYEFORD FOOTBRIDGE, *c.* 1915. Yet another Wycliffe College canoe near the Canal Cottages adjacent to the swing bridge, which crossed the canal to Ryeford Corn and Saw Mills.

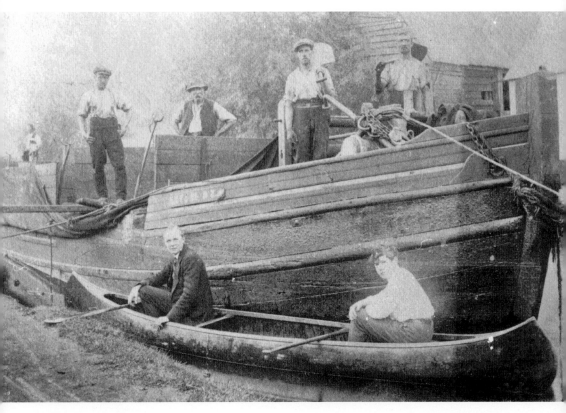

RYEFORD SAW MILLS WHARF, *c.* 1915. A trow unloading at the wharf. Note the wooden partitioning boards across the hold, the canvas side-sheets and the large shovels used in unloading.

RYEFORD MEADOWS, *c.* 1910. A photograph probably taken for the college oarsman and thought to be on the stretch of canal below Ryeford Locks.

RYEFORD MEADOWS, *c.* 1912. The long pound from Ryeford Swing Bridge up to Ryeford Double Lock with the lock cottage just discernable in the distance.

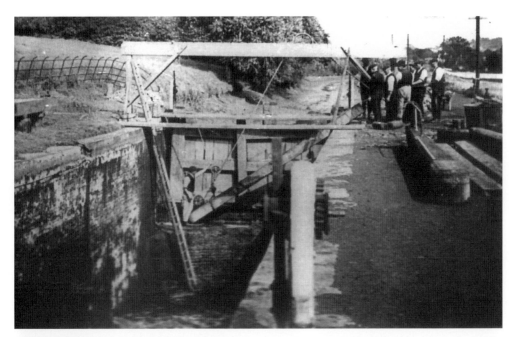

RESTORATION AT RYEFORD LOCKS.

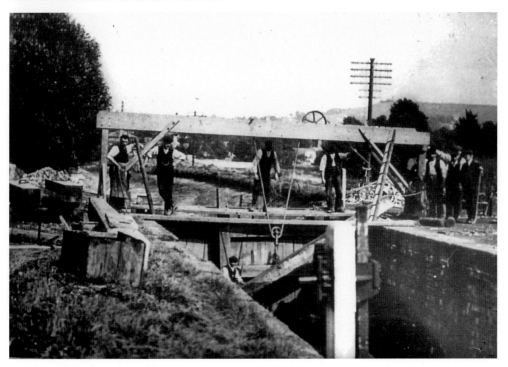

RESTORATION AT RYEFORD LOCKS. The canal is empty of water and new gates are being installed at the top of the upper lock. The top picture shows a contemplative gathering whilst the bottom picture shows a more active group.

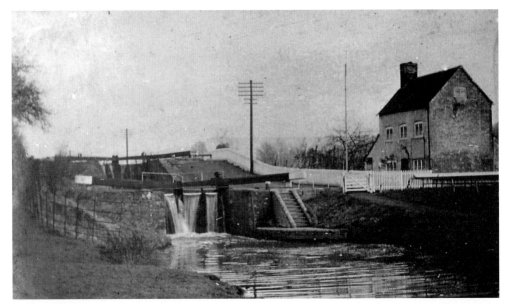

RYEFORD LOCKS, *c.* 1910. The lock chambers were always troublesome due to the unstable ground in which they were built. They were the only double-chamber locks on the Stroudwater Canal and are shown here with the lock cottage after restoration.

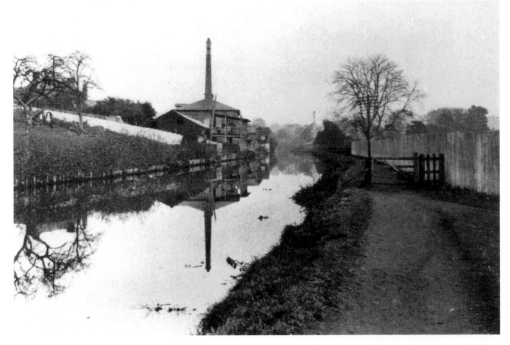

EBLEY MEADOWS, *c.* 1912. The view eastwards with Ebley Saw Mills on the left and Ebley Mills chimney visible in the distance. At centre right the footpath to King's Stanley leaves the towpath.

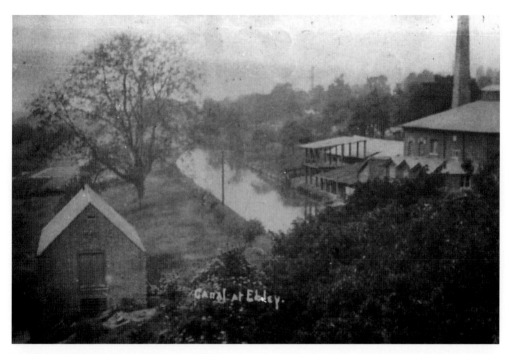

EBLEY MEADOWS. Another view of the same stretch but looking westwards from above the sluice opposite Ebley Saw Mills. The mills had their own wharf.

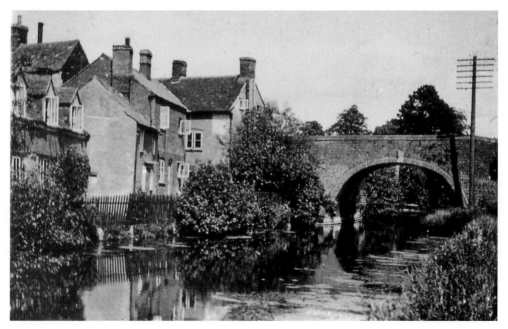

OILMILLS BRIDGE, *c.* 1910. Ebley Wharf was on the left and some of these buildings were occupied by workers on the wharf and/or connected with the canal. There was also an inn called the Bell here.

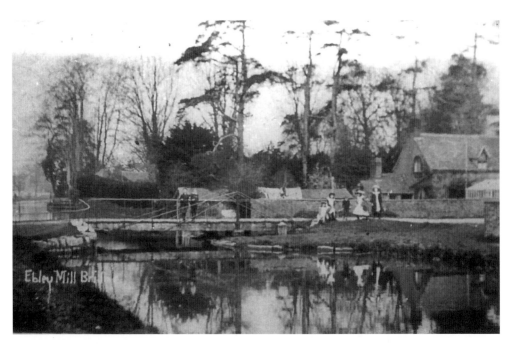

EBLEY MILLS BRIDGE, *c.* 1900.

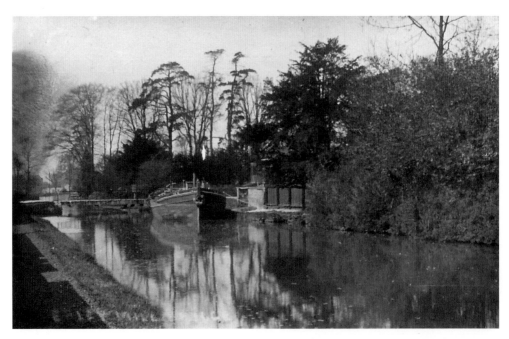

EBLEY MILLS BRIDGE, *c.* 1910. Both the above are views looking westwards at the swing bridge from the Mill Wharf. These views of this stretch are adjacent to the Stroud District Council Headquarters.

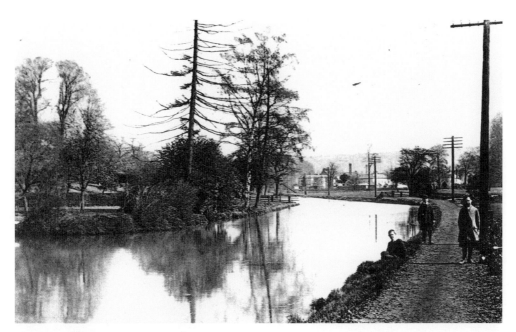

DUDBRIDGE MEADOWS, 1907.

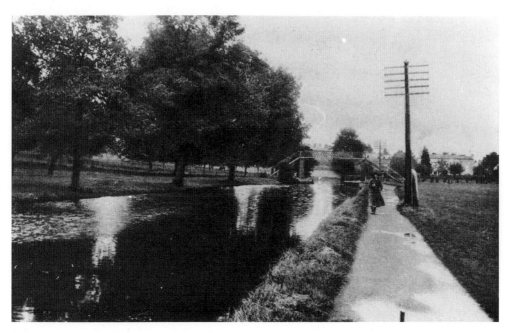

DUDBRIDGE MEADOWS, *c.* 1920. This is the pound from Ebley Mills Bridge to Hilly Orchard Bridge. Part still contains water in the reduced-width flood channel which now crosses to the river along this pound. A small estate has been built on the land to the left of Hilly Orchard Bridge.

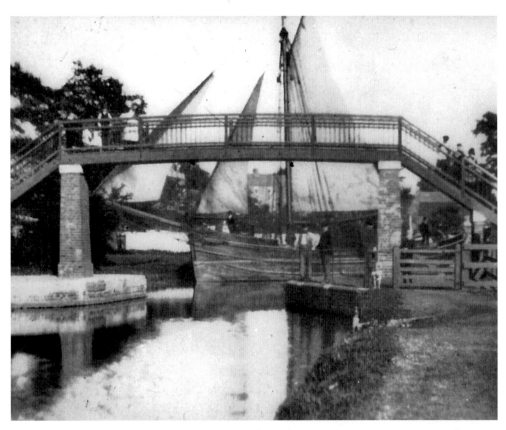

HILLY ORCHARD BRIDGE, *c.* 1907. A view from the west showing a trow approaching the bridge from Dudbridge Wharf. The sails and mast would have to be lowered to pass under the bridge. With all the people standing on the bridge and the trow with raised sails, this is probably a posed picture. The bridge was dropped down to ground level about forty years ago.

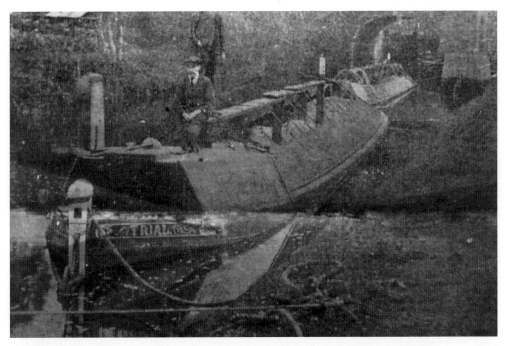

DUDBRIDGE, 1907. The barge *Trial*, belonging to Smart's of Chalford, with a butty, moored at Dudbridge Wharf just west of Dudbridge Lock which can be seen through the arch of the bridge.

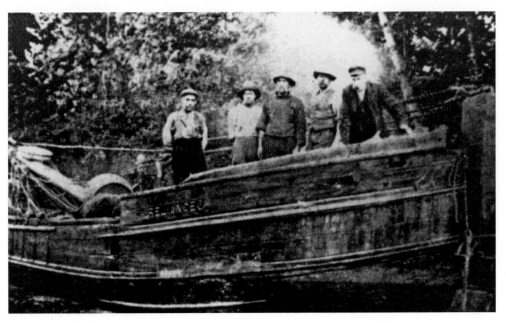

STROUD GASWORKS WHARF, 1939. The trow *Reliance* hauled coal regularly to the gasworks before the Second World War and is seen here at the wharf after unloading.

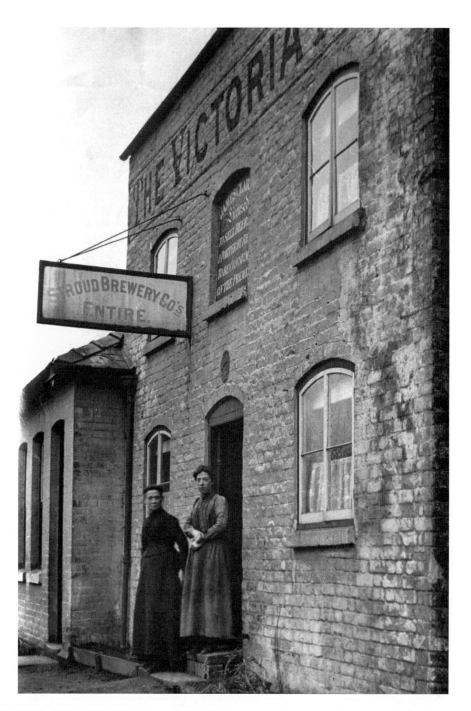

VICTORIA INN, DUDBRIDGE, *c.* 1910. This was a canalside inn adjacent to Dudbridge Upper Lock, or Foundry Lock as it was also known. It is now demolished, the site being part of the Marling School lower playing fields. Annie Clark, the licensee, is standing in the doorway with her daughter.

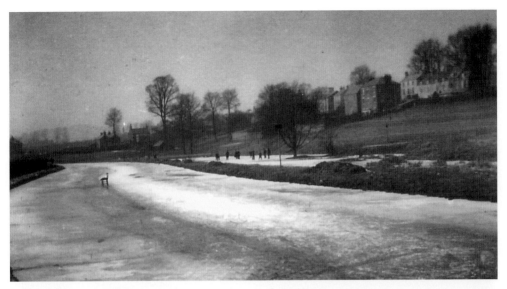

LODGEMOOR PONDS, *c.* 1890. This view, looking west along the frozen canal, shows the pound between the Gasworks Swing Bridge and Lodgemoor Swing Bridge. It is obviously a paradise for local skaters even though they have left their chair and forsaken the canal for the old millpond at Lodgemoor Mills. At this point a much wider pond had been narrowed and lengthened to give a similar volume, thereby freeing land for the canal.

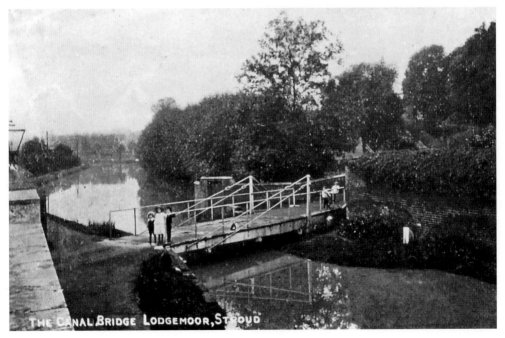

LODGEMOOR SWING BRIDGE, *c.* 1905. This bridge provided access to Lodgemore Mills and linked with the other access which branched from the Bath Road opposite the Clothier's Arms. The view depicts the scene westwards towards the site of the previous picture.

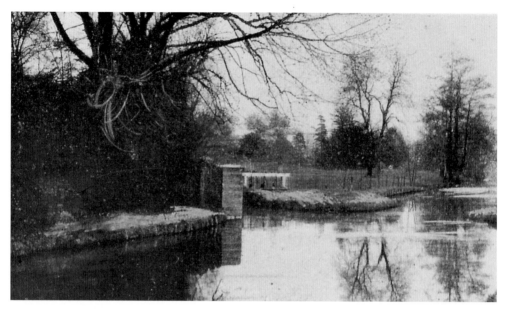

LOWER GANNICOX, *c.* 1910. At this point the Painswick Brook enters the reduced canal. Originally it passed under the canal to another millpond at Lodgemore Mills. On its left there was a winding hole. The land on the left was part of the Far Hill Estate owned by Benjamin Grazebrook, one of Stroud's eighteenth-century entrepreneurs and a leading light of the Stroudwater Canal Company.

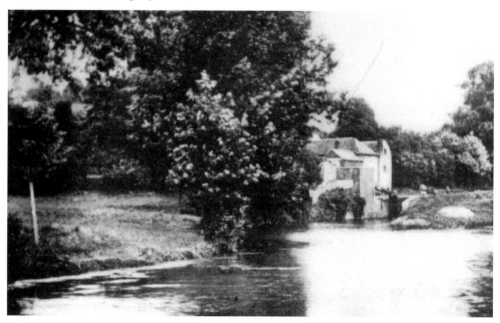

WALLBRIDGE JUNCTION, 1910. The Stroudwater Canal entered its terminal basin to the right of the picture, whilst in the centre is the junction of the Thames & Severn Canal with the Stroudwater's terminal basin. The Wallbridge Lower Lock leads out by the side of the buildings.

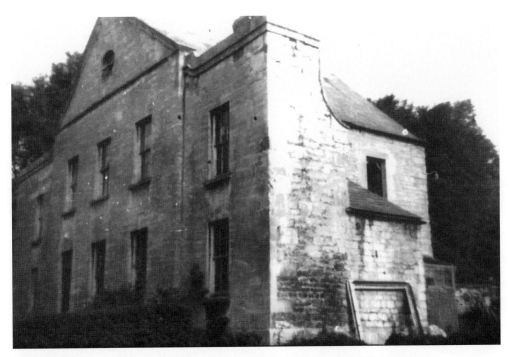

WALLBRIDGE, *c.* 1940. The headquarters of the Stroudwater Canal Company.

WALLBRIDGE, 1957. The Thames & Severn Canal, after leaving the Stroudwater Canal Basin, was raised in the first quarter mile by the two locks at Wallbridge. This picture shows the derelict canal between these two locks. The buildings on the right were part of the Stroud Brewery and the lower building still remains. All the other buildings were demolished when the north-south bypass from Merrywalks to the Bath Road was built some forty years ago, leaving this small portion of canal as a stagnant pool.

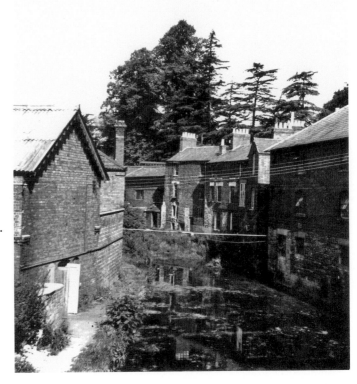

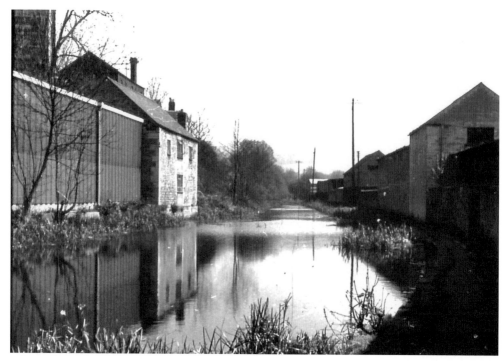

WALLBRIDGE, 1975. This is the pound above Wallbridge Upper Lock where on either side there were once the Thames & Severn Canal Wallbridge wharves. The stone building on the left is the old storehouse and the buildings on the right are now part of a builders' merchants yard. It was planned to fill this stretch when constructing the Stroud east-west bypass, but common sense prevailed, although the bypass blocks the far end of this section.

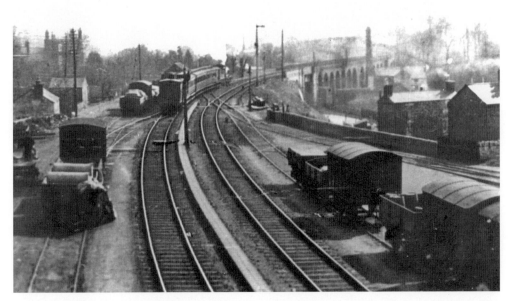

STROUD GWR GOODS YARD, *c.* 1900. Although strictly a railway picture, this shows the view eastwards from the goods shed with a train about to cross the iron canal bridge onto Capels Viaduct. A portion of the canal can be seen below the iron bridge. The coming of the railway heralded the demise of the canal which eventually passed into the hands of the GWR in the 1880s, the latter acquiring it to prevent a Midland Railway-supported Thames and Severn Railway being built along its course from Stroud to Siddington.

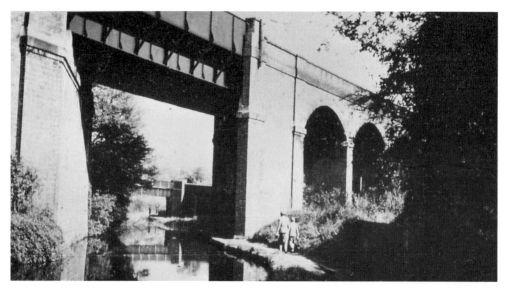

IRON BRIDGE AND CAPELS VIADUCT, 1955. A pleasant scene and one familiar to those who twenty-five years ago used to enjoy a Trust boat-trip along this stretch of canal. The east-west bypass now passes under this bridge. In the distance there is another iron bridge (see next picture) which took a dirt road from the London Road into the eastern end of the Midland Railway yard. This was frequently and unofficially used before the Second World War by local people to bypass Stroud streets.

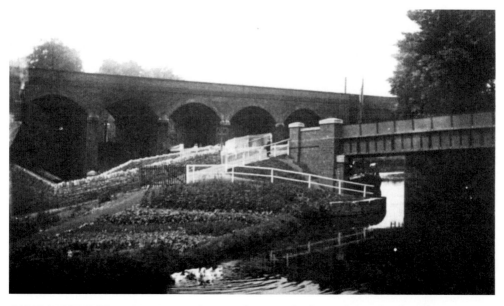

CAPELS VIADUCT, c. 1900. A view showing the access bridge to the Midland Railway yard and its stables (see next picture). At this point the canal towpath crossed from the south to the north bank as the painted handrails show. Note the trow between the two bridges.

CAPELS MILL AND VIADUCT, *c.* 1905. The mill buildings were on either side of the viaduct. To the upper right can be seen a low building with five openings along its side. This was the Midland Railway stables, a two-storey building in which the wagons were kept on the ground floor and the horses went up a ramp to the stables on the upper floor. Note also the steam railcar crossing the viaduct and about to pass over the River Frome.

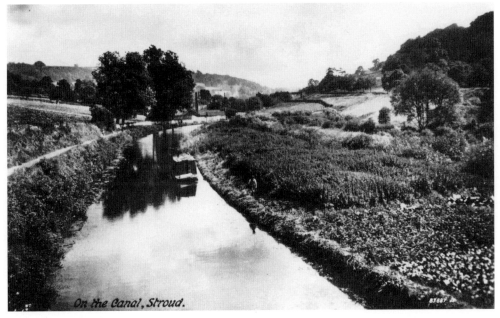

ARUNDELS MILL POUND, *c.* 1905. The same stretch of canal as the previous picture but viewed from the west with Arundels Mill behind the trees. Workmen from the canal work boat appear to be engaged in clearing the right-hand bank.

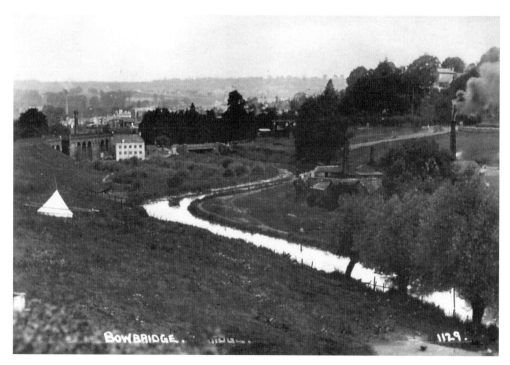

ARUNDELS MILL POUND, *c.* 1905. This view, looking west from Bowbridge, shows how the canal twisted to avoid Arundels Mill. The mill, which had its own canalside wharf at this time, would have been the dye works of Gyde, Bishop & Co.

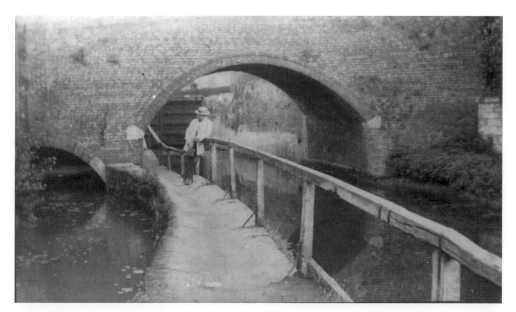

BOWBRIDGE, *c.* 1910. Here, only the towpath width separates the canal and the River Frome. Not the best of pathways for an inebriated bargee! The lower gates of Bowbridge lock are visible through the bridge.

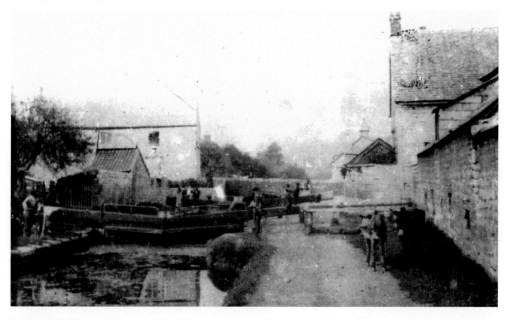

BOWBRIDGE LOCK, *c.* 1910. This appears to be a posed picture but on the left a man is operating a sluice paddle whilst two donkeys are patiently waiting on the towpath. We can therefore surmise that the lock holds a barge. All locks from Stroud to Bourne were wide enough to take trows. A concrete dam has now replaced the upper lock gates to keep the correct depth of water in this section.

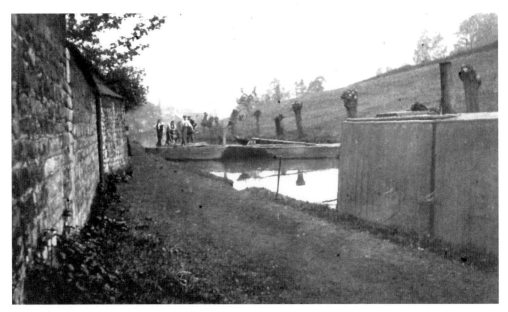

BOWBRIDGE POUND, 1911. This shows the mud-clearance boat just above Bowbridge Lock, with the long-handled mud scoop lying across the right-hand boat. The work boat lies to the right and in the distance can be seen the chimney of Stantons Mill.

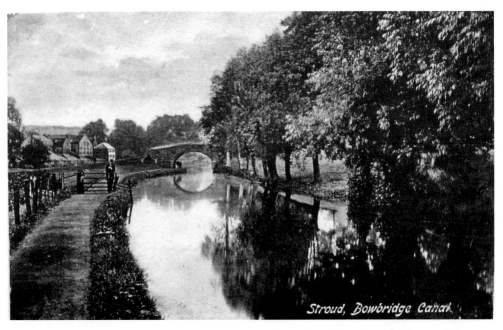

STANTONS BRIDGE, *c.* 1910. The bridge is one of several in the valley which provided access to the mills for workers from the villages on the valley slopes. The towpath was gated to prevent animals straying from the fields through which the canal passed. In fact, there appears to be cattle on the towpath under the bridge. This is now a cleared and restored section of the canal.

GRIFFINS LOCK, *c.* 1885. This view from the east shows a barge in the lock chamber coming up the canal. The bargee appears to be somewhat disgruntled. Note the overflow on the right protected by the wooden handrail.

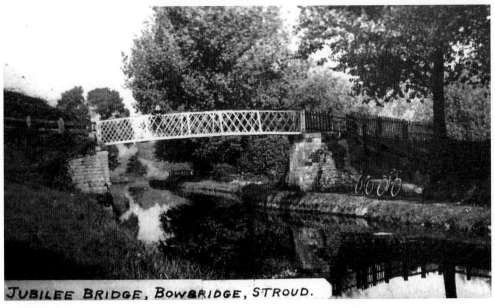

JUBILEE BRIDGE, BOWBRIDGE, STROUD.

JUBILEE BRIDGE, *c.* 1920. Another footbridge providing access to Griffins Mill. It is thought it was erected to celebrate the Golden Jubilee of Queen Victoria in 1887 but there are conflicting dates for its erection. It replaced a temporary bridge of 1842 which itself was built to restore a right of way over a collapsed original bridge.

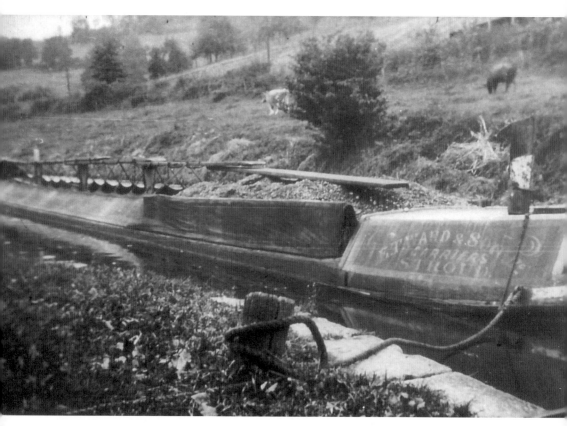

HAM MILL WHARF, 1934. A barge of E. T. Ward & Son, coal merchants of Stroud, moored at the wharf just above Ham Mill Lock. It had brought the last load of coal by water to Ham Mills before the final closure of the canal.

BAGPATH POUND, *c.* 1885. The view west from Bagpath Bridge towards Ham Mill Lock.

HOPE MILL LOCK,
c. 1910. Also known as Ridlers
Lock. The buildings on the right
were originally a woollen, and
later a silk, mill. The building on
the left was constructed by the
boat-builders Abdela & Mitchell
(see following pictures) as offices.
The lock and canal are now
infilled.

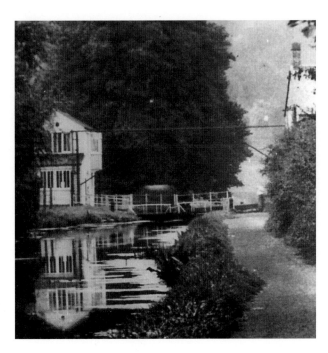

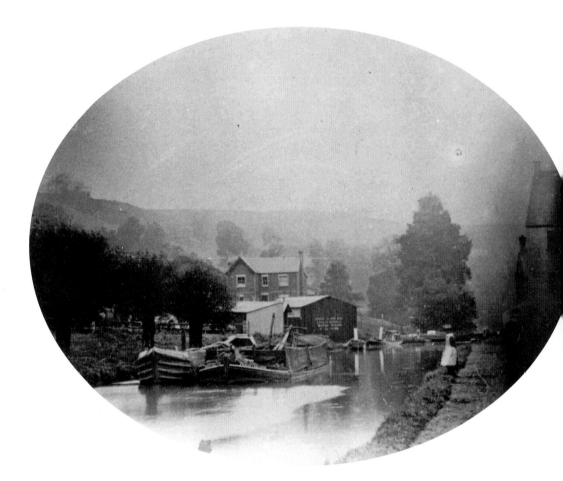

EDWIN CLARK'S BOATYARD, *c.* 1885. Beyond the girl standing on the towpath is the upper gate of Hope Mill Lock, and the end of Hope Mill is to the right. On the left is Clark's boatyard with, behind it, his house, Hope Villa. Edwin Clark commenced boat-building here in 1878, at first building a variety of craft mainly for use on European rivers, two typical small steamlaunches being moored by the shed. He also built several boats for Salters for use on the middle and lower Thames. The barge in the foreground, the *Perseverance*, was owned by James Smart of Chalford. A picture of it in a derelict condition on the canal bank at Ryeford is shown in *Britain's Canal and River Craft* by E. Paget Tomlinson.

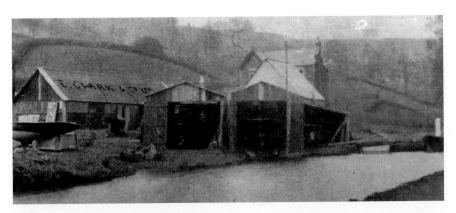

EDWIN CLARK & CO. BOATYARD, 1898. A later view showing boats on the stocks outside while others can be seen in the sheds and on the canal. Clark had enlarged his business into a thriving concern and in 1889 had entered into partnership with Sissons of Gloucester. The business continued to thrive, building boats for South America and Africa. In 1897 Clark died whilst still a young man, the business being bought by Mr Earle who would have been the owner when this picture was taken. In 1899 the business was sold to Isaac J. Abdela & Mitchell of Manchester who continued boat-building here until the Second World War. Boats could be despatched under their own power down the canals, or sectioned and sent by barge/trow to the Gardiner Boatyard at Saul for reassembly before proceeding to Sharpness for shipment. Some boats were also sent by rail from Stroud and, after closure of the canal in 1934, this method would have been used together with road transport.

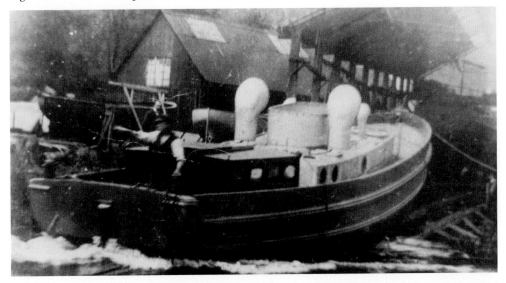

CLARK'S BOATYARD, ALSO USED BY ABDELA & MITCHELL, was commonly called Brimscombe Boatyard. Here a boat is being launched into the canal. Both sideways and angled launching methods were used because of the limited canal width. This boat is a wooden Harbour Service Launch built for the Admiralty in 1915. Another is by the adjoining shed. Many were built in small yards nationwide during the First World War.

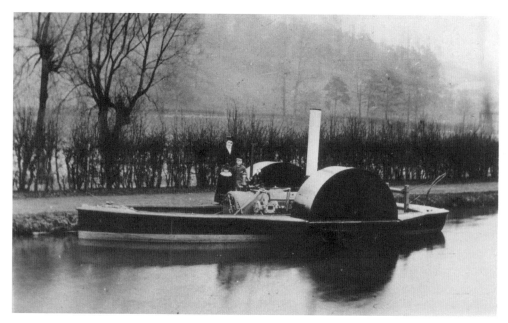

AN EDWIN CLARK PADDLE BOAT in the Hope Mill Pound in 1893. The figures on the towpath are believed to be Mrs Clark and her son. The boat was built for the Commissioners of the River Idle (a Fenland River), which, we are told, is now too silted up to take such a boat.

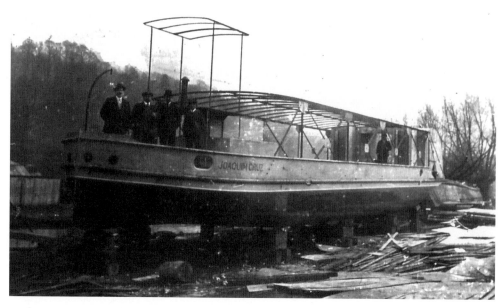

ON THE STOCKS IS THE *JOAQUIM CRUZ*, a quarter-wheeler steam boat. She was built in the 1905-10 period. Mr Abdela is on the left.

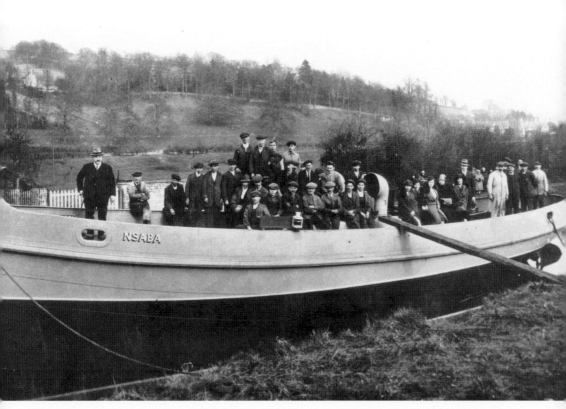

AN ABDELA & MITCHELL STEAM TUG, *Nsaba*, moored alongside the yard with what is probably the whole workforce on board. The name of the tug suggests an African destination. Mr Abdela is the gentleman on the left and this boat was built in 1927, three years before his death.

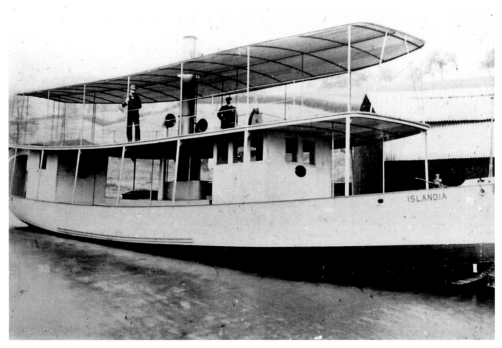

ONE OF THE LARGE TWIN DECKED STEAMERS built for both cargo and passengers by Abdela & Mitchell; the *Islandia* moored alongside the yard. She was seventy-three feet long, fitted with a compound engine and destined to work on the River Amazon.

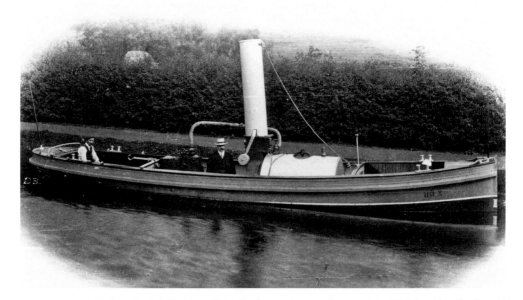

THE *IBEX* WAS AN OPEN STEAM TUG built in 1906, and again Mr Abdela is by the funnel with Mr Earle, the Works Manager, seated in the stern.

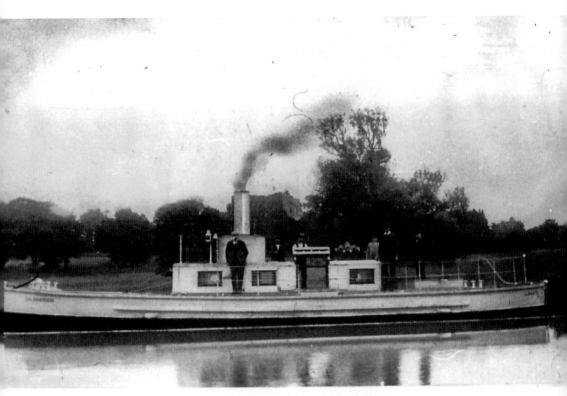

THE YARD ALSO BUILT FIRE FLOATS such as the *Salamander,* for use in Gloucester Docks and stationed at Llanthony Bridge, and the *Fire Queen* for Cardiff. The *Salamander* was built in 1906 and was propelled by water jets, two in the bows and two on the quarters, and was fitted with Merryweather fire pumps.

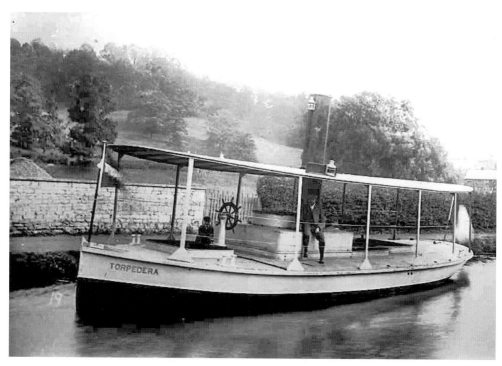

A DECKED AND CANOPIED BOAT, *Torpedera*, destined for Brazil. She was fitted with a compound steam engine and is shown here moored east of Hope Mill.

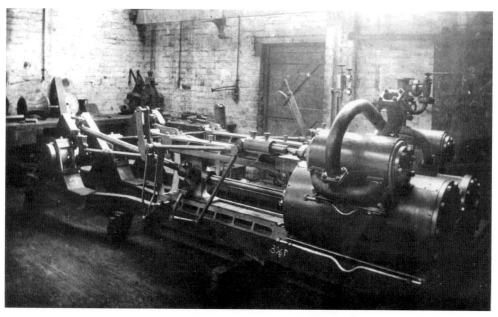

A COMPOUND STEAM PADDLE ENGINE probably in the Hope Mill engineering works.

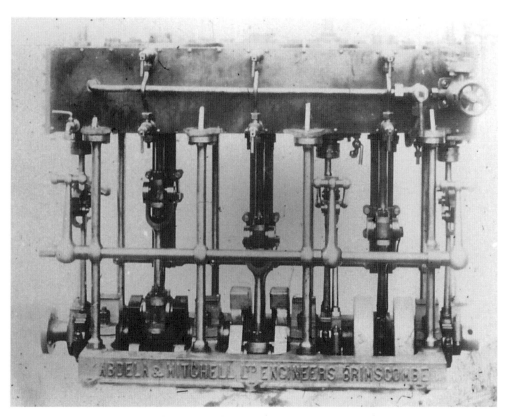

A TRIPLE EXPANSION STEAM ENGINE.

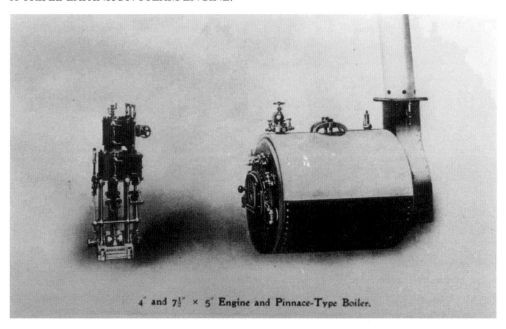

4" and 7½" × 5" Engine and Pinnace-Type Boiler.

A COMPOUND STEAM ENGINE AND ITS PINNACE-TYPE BOILER.

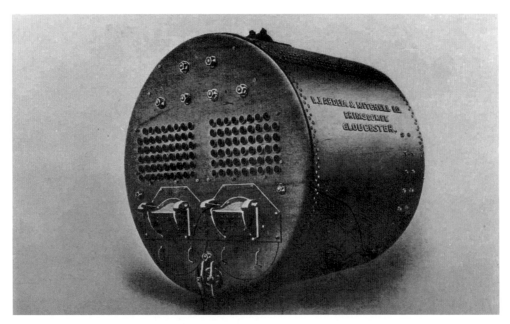

A TYPICAL, LARGE DOUBLE-FIRED BOILER.

GOUGHS ORCHARD BRIDGE AND LOCK, c. 1950. Part of Brimscombe Upper Mills is on the left. The canal still has some water in it although it is derelict. The rough track on the right is wide enough to take the traffic along from Brimscombe Hill to the firm now occupying the old Abdela & Mitchell boatyard site.

BRIMSCOMBE UPPER MILLS, *c.* 1900-10. Unloading coal into the mills using a two-man hog from the longboat *Albert*. This boat was one of the barges owned by A. M. Pearce, the canal carrier of Brimscombe, who was well known on the Thames & Severn Canal. The two bargees were Chalford men, both named Davis, but not related.

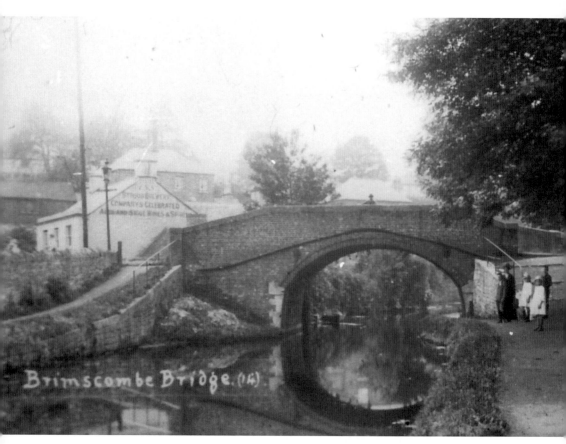

BRIMSCOMBE BRIDGE, *c.* 1912. This bridge took the road from Brimscombe to Minchinhampton over the canal. The view is of the east side of the bridge, the cranked pipe being a gas main linked to a small gasometer sited behind the tree on the right. On the left is the Ship Inn which, along with the Port Inn by the headquarters building and the Nelson Inn further up Brimscombe Hill, provided the bargees with sustenance. Towpaths are on both sides of the canal here as it approaches Brimscombe Port, that on the right leading to the main road by the Port Inn and that on the left leading to the West Wharf of the port.

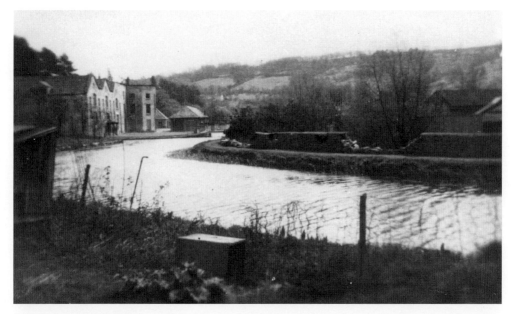

BRIMSCOMBE PORT, *c.* 1920. The view of the Thames & Severn Canal headquarters, warehouses, and manager's house as seen by bargees approaching from Stroud.

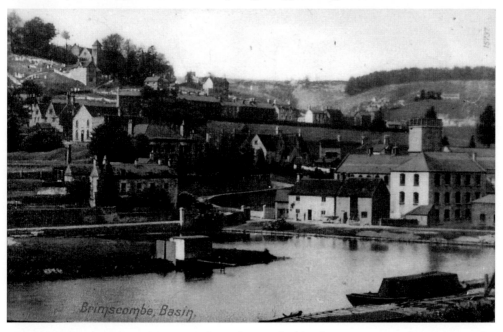

BRIMSCOMBE PORT, *c.* 1908. View from the North Wharf over a corner of the basin to the West Wharf with the end of the island on the left. The large buildings of Brimscombe Port Mills lie to the right and the white cottage in front of them was the lengthsman's cottage, Mr Dowdeswell being the last tenant just into the 1980s. The adjoining building was the salt store and is now the only remaining building still standing out of the whole port complex.

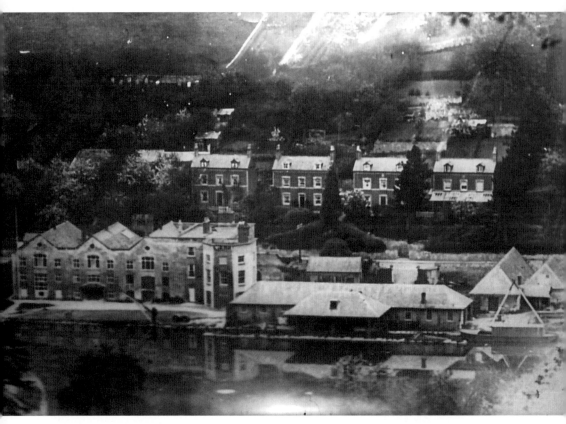

BRIMSCOMBE PORT, *c.* 1910. View from the south across the basin to the headquarters buildings. The old warehouse to the left appears to be freshly altered by the Gloucestershire County Council to form the Brimscombe Polytechnic. The multi-sided protruding part on the right, which was the Canal Manager's house, became the Polytechnic Principal's house. On the wharf edge is a typical Thames & Severn wooden wharf crane and behind the work boat, moored on the right, is a tripod gantry. The central portion of the long, low transit shed/warehouse in the middle of the picture covered the barge-weighing machinery.

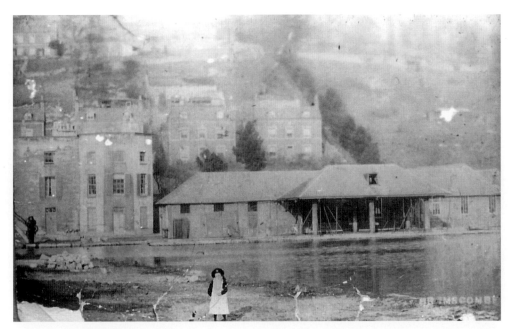

BRIMSCOMBE PORT, *c.* 1900. A closer view from the lengthsman's cottage across the West Wharf and basin towards the barge-weighing shed. Note the suspension irons of the cradle.

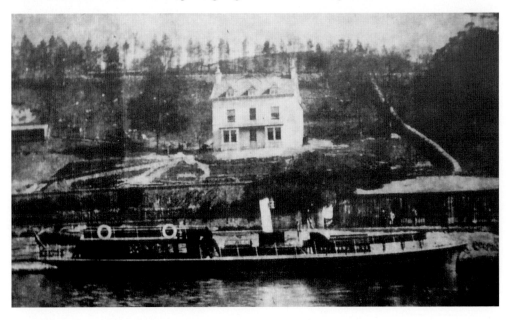

BRIMSCOMBE PORT, 1891-2. Alongside the maintenance yard is the Edwin Clark & Co. river steamer *Windsor,* built for J. Salter of Oxford and launched in 1891. The newly-built house above is Maplehurst, built for A. M. Pearce, the Brimscombe barge owner, in 1890-1. It is said that he named the house after his favourite barge, the *Maple,* but the tree to its left is also a maple, felled when it became rotten in its base in 1956.

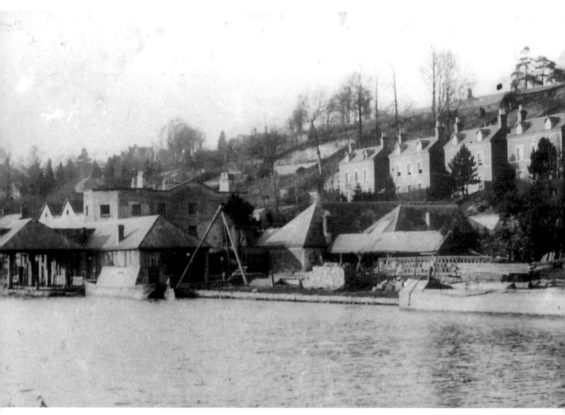

BRIMSCOMBE PORT, *c.* 1905. The east end of the port buildings and maintenance yard. On the left of the barge-weighing shed, there appears to be a mud boat and to the right is the Brimscombe-based work boat. A barge is moored extreme right, possibly a Pearce boat. Under construction in the maintenance yard is a lattice girder bridge similar to Jubilee Bridge (see page 51). The date suggests that this bridge is the one which was later erected on the Cirencester Branch Line (see page 123) in 1906.

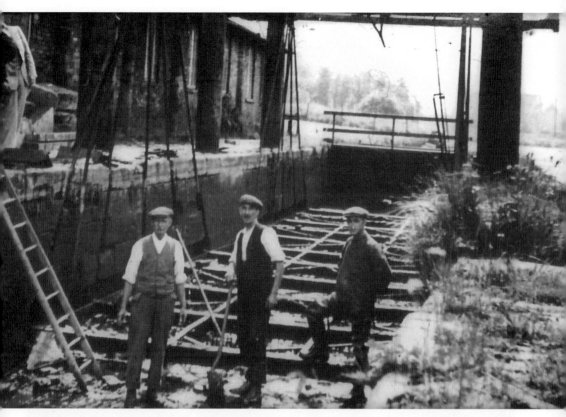

BRIMSCOMBE PORT BARGE-WEIGHING MACHINE, 1937. Workmen are dismantling the machine and its shed. On the left is Mr Stephens who worked at, and out of, this port for many years. After the machinery was taken away, the chamber served for many years as a swimming pool for local children. (GCRO)

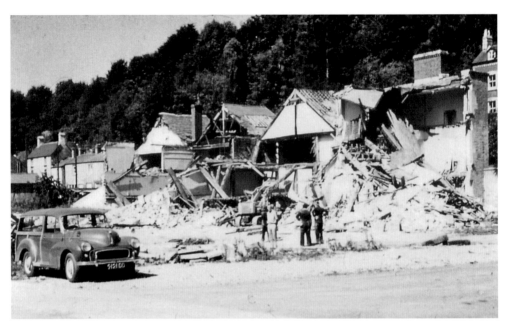

DEMOLITION OF THAMES & SEVERN CANAL HEADQUARTERS, 1962.

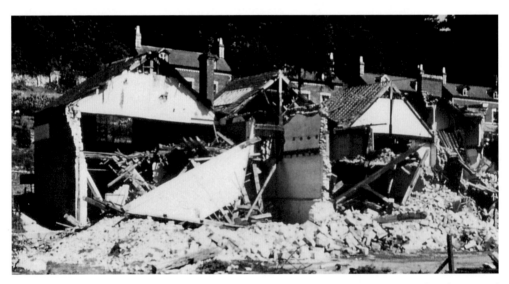

DEMOLITION OF THAMES & SEVERN CANAL HEADQUARTERS, 1962. After the Second World War, the Brimscombe Polytechnic became the Brimscombe Secondary School until 1961, when it moved to Manor School at Eastcombe. The buildings were purchased by an adjacent engineering company, Bensons, and demolished to make room for modern offices and production buildings. So passed the headquarters of the Thames & Severn Canal Company and with it the Stroud Valley's inland port. A plaque affixed to the present office wall gives a brief history of the site.

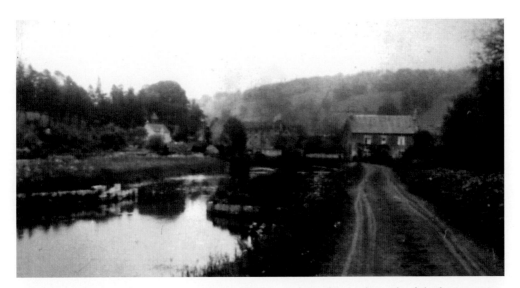

BRIMSCOMBE PORT BASIN, *c.* 1910-20. View east along the south reach of the basin, a view that is rarely shown because of its apparent lack of interest. The narrow masonry waist could be bridged for access to the island on the left. In the centre is a warehouse, a foundry and Bourne Mills, while the cottage to the right was once another warehouse. The road shown runs between the basin and the River Frome.

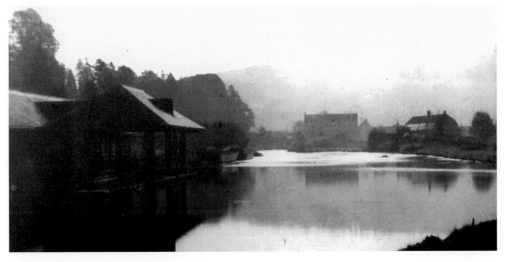

BRIMSCOMBE PORT BASIN, *c.* 1900. The view east along the main section of the basin towards Bourne or Hacks Mill (compare with page 72). On the right is part of the island, the building thereon being another warehouse. The valley was wide enough here to allow the construction of this large transhipment port and storage area. Transhipment was necessary so that goods could be moved from the wider Severn trows and barges to the narrower Thames boats to complete the through navigation of the canal. It is said that the island deterred the theft of cargo. Perhaps, in another way, Brimscombe Basin foreshadowed the saga of Gloucester railway stations in the broad- versus narrow-gauge controversy.

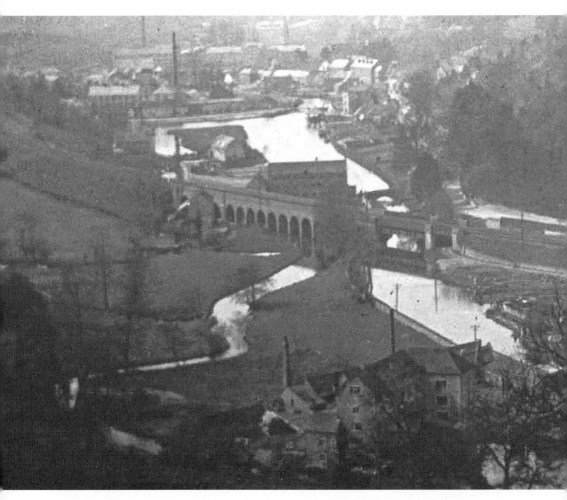

BRIMSCOMBE BASIN, *c.* 1905. A telescopic view looking west over the whole port basin from Knapp Hill, which shows just how vast the area was that the basin occupied. Points of interest are many but note (1) the warehouse on the island; (2) the road, canal and railway positions; (3) the entrances to the dry docks of the Bourne shipyard on the right. This yard was built by the Thames & Severn Canal Company for building and repair of canal boats; (4) Dark Mills in the foreground; (5) the River Frome and cut mill stream.

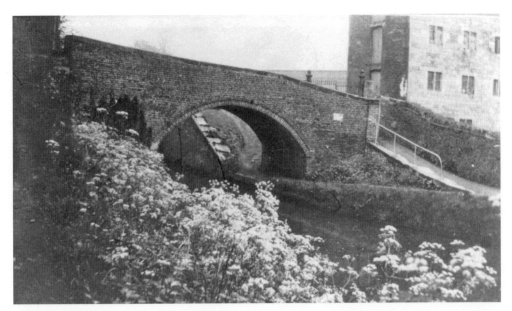

BOURNE BRIDGE, 1911. The bridge gave access to Bourne (Hacks) Mill, an old woollen mill, now a small industrial estate. This view, from the eastern exit of the basin, shows the beginning of Bourne Lock chamber. This lock was the last lock eastwards from Stroud which was wide enough to take the Severn trows/barges and consequently it was possible to build trows at the boatyard just beyond the lock.

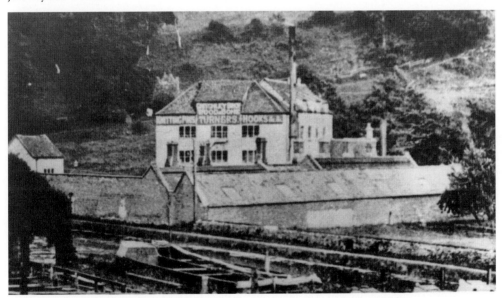

BOURNE BOATYARD, c. 1907. This view of Dark Mills at the Bourne was taken soon after they were acquired by Critchley Bros. In the foreground is the dry docks area of the boatyard with some moored barges. These may have been newly built or awaiting repairs. The site is now part of the Olympic Varnish Co.

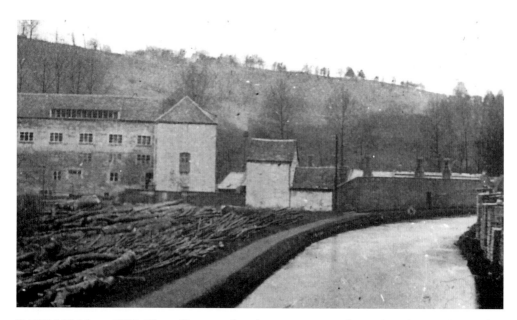

DARK MILLS, *c.* 1898. The mills were then in use as saw and wood-working mills. Timber would have been brought to the site by horse wagons or barge. The sawn stacks of timber on the right are evidence of the other saw mill on the north bank of the canal, the site of which is now also occupied by the Olympic Varnish Co. The proprietor of this saw mill would have been Philpotts, known locally as 'Lord Sawdust'.

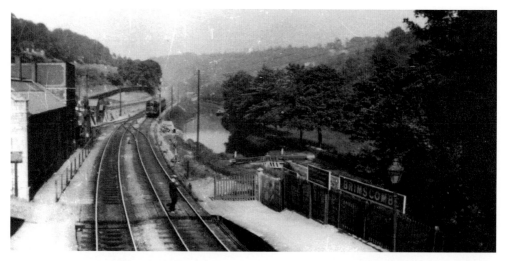

BEALES LOCK, *c.* 1930. The lock, adjacent to the eastern end of Brimscombe station, from the bridge of which this photograph was taken, has always retained a good depth of water up to St Mary's Lock. This was because water was drawn from it to supply the Brimscombe banker engines whose shed, with the water tank on its roof, is seen on the left. Note the barge going up the canal, almost certainly a Smart barge from Chalford, and also the Chalford–Stonehouse railcar stopped by the down signal.

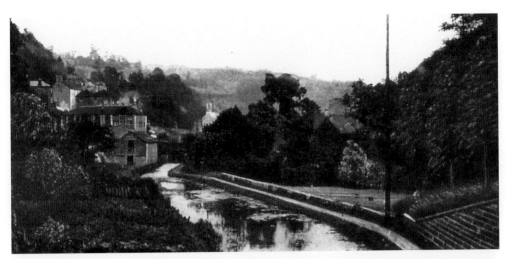

ST MARY'S, *c.* 1910. The view from St Mary's Halt towards the pound above St Mary's Lock. Today it is an overgrown and narrowed stretch. The large building on the left was Clayfields Mill worked by a water-wheel driven by a small stream coming off the hill to the left, which then passed under the canal to the River Frome. The river is separated from the canal only by the towpath at this point where the canal bends to the right. There was also a spillway from the canal into the river here.

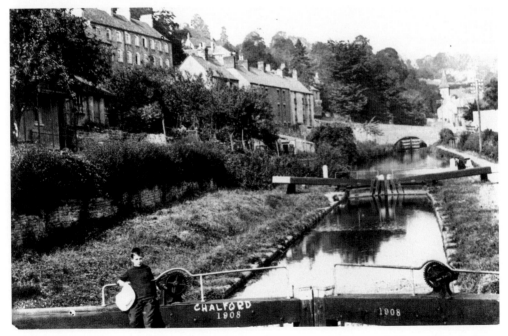

ILES LOCK, *c.* 1915. Taken from Iles Bridge looking east to Ballingers Bridge and Lock. Note the restoration dates on the lock gates, 1912 on the upper gates and 1908 on the lower gates. This was always a favourite fishing haunt as witness the two sitting near the upper gate balance beam.

BALLINGERS BRIDGE, *c.* 1920s. A donkey towing a barge towards the bridge. The bargee was a well-known Chalford man, Tubby Franklin, so the barge must have been one of Smart's approaching the last lock before home. A regular trip for Tubby was up to the Staffordshire coalfields; donkey power to Gloucester, steam tug to Worcester when the donkeys rode on the barge, then donkey power again to the coalfields.

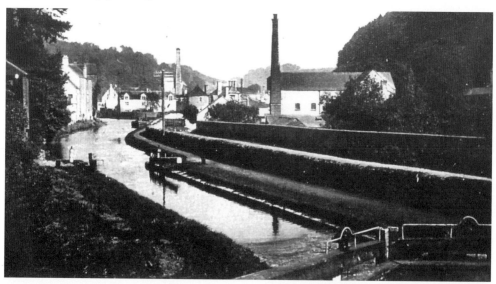

BALLINGERS LOCK, *c.* 1910. Above the lock the canal became slightly wider as it approached Chalford Round House Wharf and Smart's Wharf. A barge is moored at the wharf and to its right are the entrance gates to the wharf and the round house. The mill to the right is Chalford (alias Ballingers, Belvedere, Clarks) Mill. At this time it would have housed Clark's Corn Mills and agricultural engineering business. Later it was to be the second pumping station for Stroud Water Co.

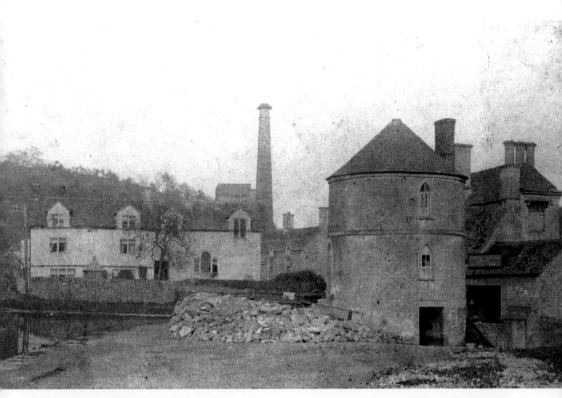

CHALFORD ROUND HOUSE AND WHARF, *c.* 1900. Perhaps the best known of the Thames & Severn Canal round houses, built as lengthsmen's cottages, and containing four storeys. Today it is a renovated private house. The stone edging to the wharf can be seen on the left and the edge of a spillway on the right. The load of stone on the wharf could have been for road repair. The house on the left, facing the wharf, is Greystones (now Wharf House), the home of James Smart the Chalford barge owner. In 1825 when David Farrar came from London to live in Belvedere House close by, and set up his dye works locally, he brought his furniture by barge to be off-loaded here and carried across the road.

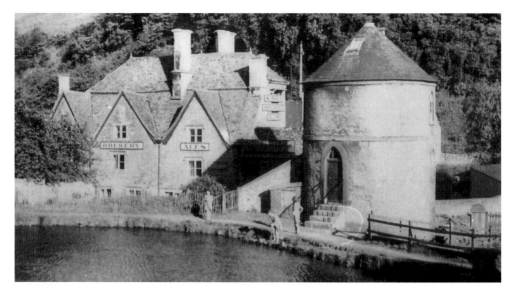

COMPANY'S ARMS, CHALFORD, *c.* 1930s. This inn, across the road from the round house, is one of Chalford's oldest dwellings and has now been restored, reverting to its old name of Chalford Place. It was a coaching inn in the early nineteenth century, the proprietor running coaches to London, Gloucester and Bristol.

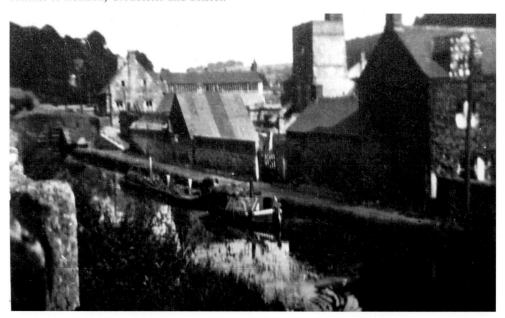

SMART'S WHARF, CHALFORD, 1932. A barge is unloading coal. Wheelbarrows or hogs were used to take the coal through the gate into the yard. At this time the business was owned by James Smart's son Harry, under the name of J. H. Smart & Sons. It is still possible to read the badly weathered lettering on the north-facing end wall of the house which advertised Smart's business. To the left is Chapel Bridge with the lower gates of Chapel Lock just visible through the arch.

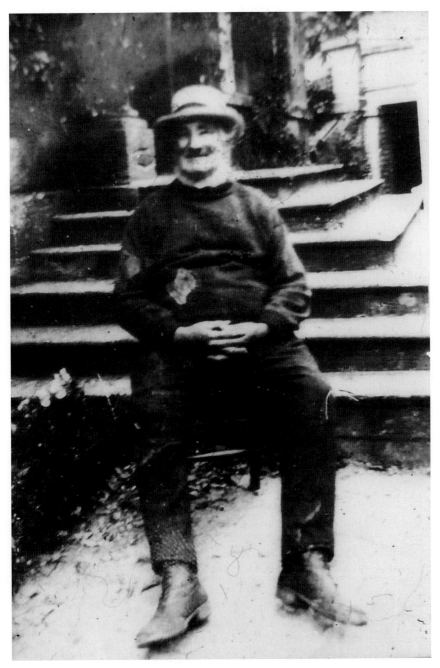

JAMES SMART, BARGE OWNER, *c.* 1900-10. The eldest boy of the family, left fatherless before he was ten years old, his business acumen was such that he built up his canal-carrying and coal-merchanting business whilst virtually uneducated in the now accepted sense. The coal merchants business still survives under other ownership elsewhere in the valley.

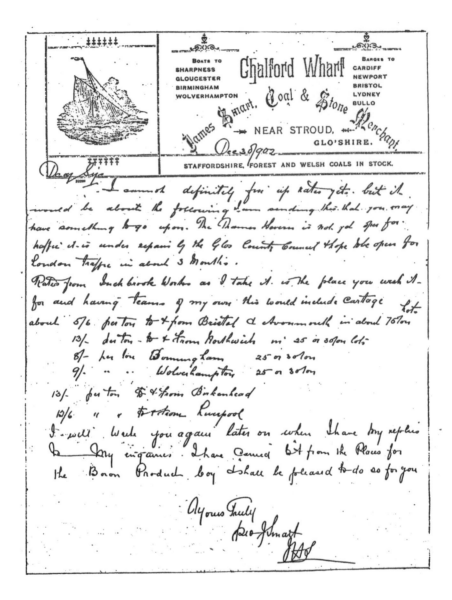

A COALMERCHANT'S QUOTATION, 1902. Copy of a letter from James Smart of Chalford Wharf to Inchbrook Works in the Nailsworth Valley, mentioning the closure of the canal for repairs by Gloucestershire County Council. He indicates that his own haulage by road from a canal wharf is included in the quotation.

CHALFORD CHAPEL LOCK, 1911. Note the 1907 repair date of the lock on the top gate. Chalford Trading Estate area is behind the wall to the right.

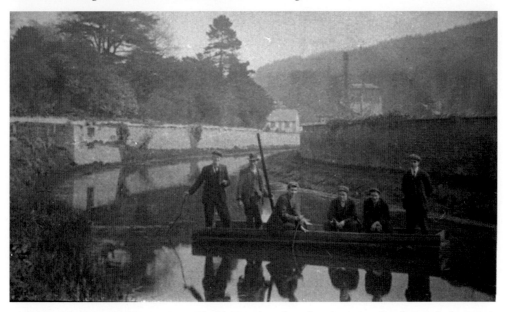

CHAPEL LOCK POUND, pre-First World War. Are they skiving, is it a lunch-time lark, or is it serious business? In a mud boat too! From left to right Ernie Crook (canal maintenance workman), next three not identified, Bob Carrington (railway ganger) and Dan Rowles. The rectangular projection on the left was a county council lay-by on the main A419 road which runs behind the wall. It was used to store road-repairing materials. For years these were brought by barge and off-loaded through the doorway seen in the canalside wall. Half the canal width has been filled along this stretch to accommodate a widened road.

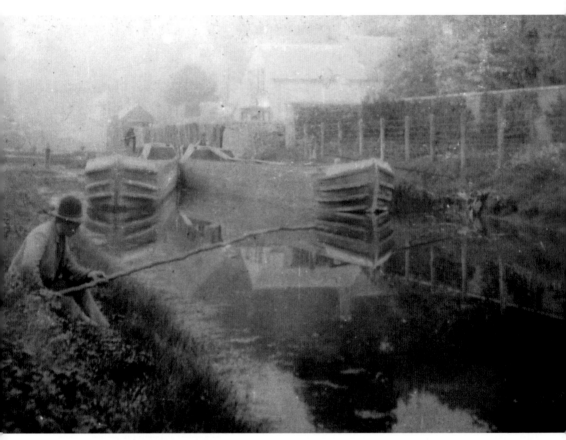

COULDREY'S WHARF, CHALFORD, *c.* 1910. This was a small coal wharf just above Chapel Lock. The barge to the right appears to have been tied up for a good time considering the weed on the mooring line. Faint in the background is Mann's General Stores (until recently Noah's Ark shop). The present-day bus shelter stands about where the bows of the left-hand barge lie.

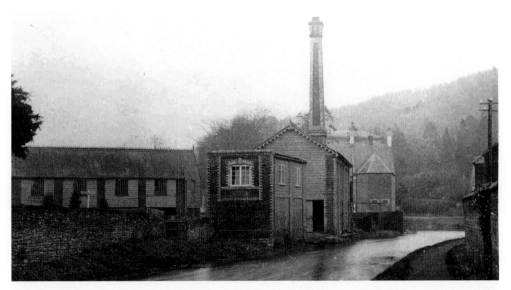

VICTORIA STEAM JOINERY WORKS, *c.* 1912. The works of Charles Smith, restored after the disastrous fire of 1906, is now called Chalford Chairs. The long building to the left was the timber-drying store standing on the road island across the road from the main building. This road island was considerably larger than it is today, accommodating a timber yard as well as a railed-off corner enclosing the finger post which was facetiously called 'Chalford Park'. The shed was demolished in 1936. The little shed to the right of the chimney was the works toilet discharging direct into the River Frome which flows under the canal at this point. The canal curves round to the left in the distance to Bell Bridge and Lock.

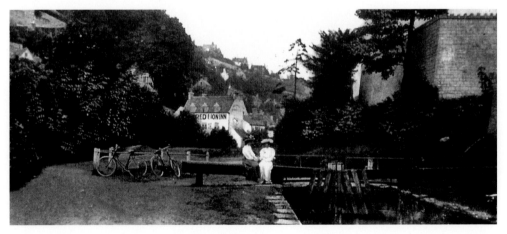

BELL LOCK, *c.* 1901. The two lady cyclists resting on the balance beam have propped their bicycles against the railings surrounding the swilly which took the overflow water to below the lower lock gates. The River Frome is behind the bushes on the left, being much lower than the canal at this point. Just beyond the swilly a footbridge crossed the river to give access from the towpath to the yard of the Bell Inn. The high wall on the right supported the goods yard of Chalford station.

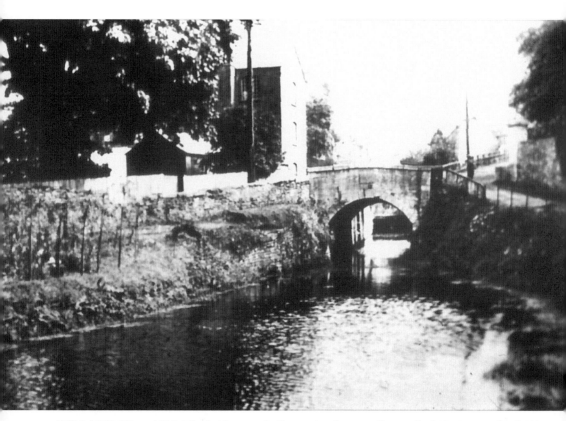

BELL BRIDGE, *c.* 1930. The bridge was built to take the turnpike road of 1815, now the A419, across the canal at this point by means of a fairly sharp-angled 'S' bend. The bridge was realigned in the 1930s to give a straighter approach to Cowcombe Hill. Bell Lock chamber can be seen through the bridge arch. The lock and canal were piped and infilled in the 1950s to enable the road to be widened and straightened.

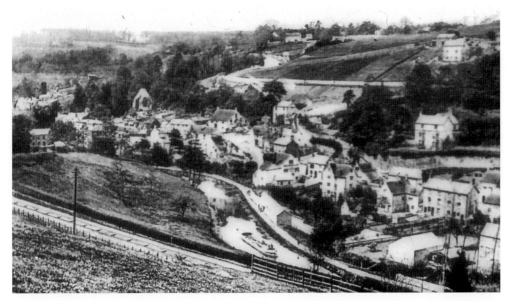

RED LION POUND, *c.* 1880. Above Bell Lock the canal swept in an elongated 'S' towards Clowes Lock. Interesting points in this picture are (1) the barge going west with the towing donkey by the skittle alley of the New Red Lion Inn; (2) the New Red Lion Inn in its old form with gables east-west which was gutted about 1885 and re-gabled north-south; (3) no Chalford station, not built until 1897, but broad gauge-type rail and sleepers; (4) the shed beyond the river to the right of the barge was part of a small yard.

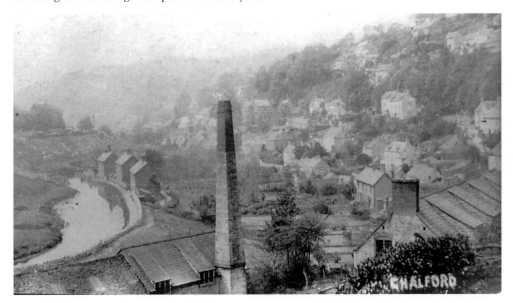

CLOWES POUND, *c.* 1905. A view from Coppice Hill over Seville's Mill to Clowes Lock showing the enlarged pound above the lock. East from this the canal becomes quite narrow for a few hundred yards (see page 86) allowing only the passage of one boat at a time.

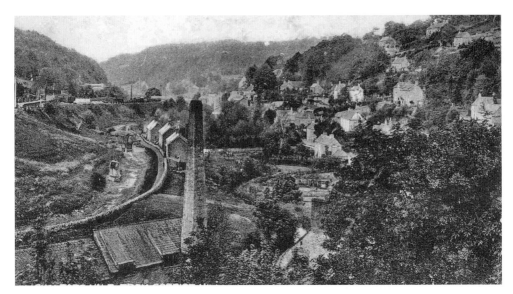

CLOWES POUND, *c.* 1920-5. Now dry with a barge marooned in the pound. The barge was the *Union* belonging to James Smart. Towards the end of the First World War, it was bringing a 70-ton load of coal up to Chalford Water Works (see page 90) and was moored in a full Bell Lock, while the bargees decamped to the Bell Inn for refreshment. They forgot that the lower gates leaked and when they returned they found the barge resting with bows on the upper sill, stern on the bottom and its back broken. The barge had to be off-loaded by hand and was then towed to its last resting place in this pound where it gradually disappeared, being used for firewood.

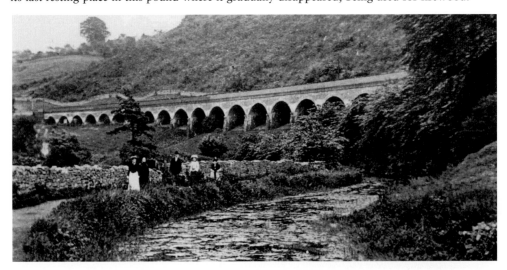

THE NARROWS, *c.* 1910. Above Clowes Pound the canal had to curve around Seville's millpond, and only the towpath separated the two. Because the hill began to rise sharply from the millpond, only a narrow cut was constructed along this length. The steepness and the instability of the hill can be gauged from the half-viaduct which the GWR engineers had to build to support the railway here where a major landslip had occurred a few years before.

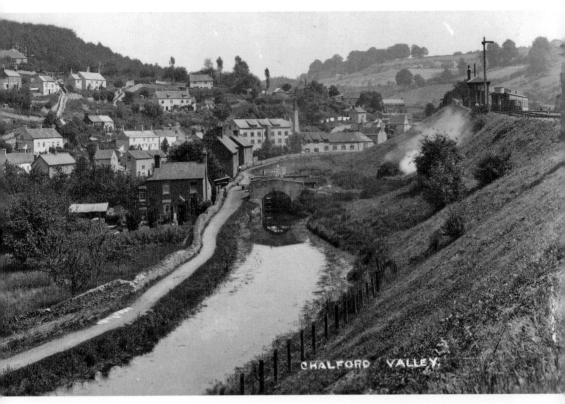

CLOWES BRIDGE, 1912. This bridge was built to accommodate one of the old pack-horse trails which linked Bisley with Minchinhampton. It is a fine bridge, the keystone being inscribed 'Clows Engr. 1785'. Josiah Clowes was the surveyor, engineer and master carpenter for the canal, perhaps best described as the Clerk of the works. Red Lion Lock, or Clowes Lock, is just behind the bridge, whilst in the distance can be seen Seville's Mill, the last working woollen mill in the Chalford Valley, demolished in 1952.

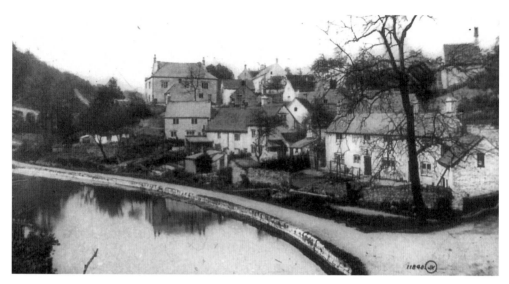

JOURNEY'S END, c. 1908. After passing the Narrows the canal became quite wide as it approached Yalley Lock, although only the towpath separated it from the river which is still on a much lower level. This may account for the stone edging to the bank, although Smart Bros, not related to James Smart, had a small coal wharf here. The last cottage on the right is known as Journey's End but was once Wharf Cottage. In the left-hand cottage of the left terrace of three lived bargee Walter Pearce (see page 18).

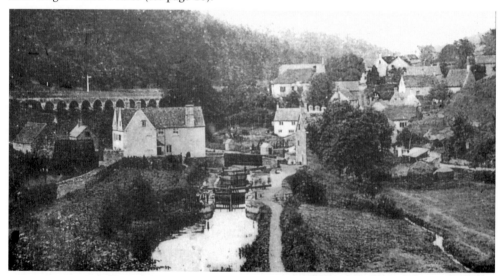

VALLEY LOCK, 1907. View west over Valley Lock and Bridge. The bridge was wooden but was replaced by an iron bridge some thirty years ago. This was again the route of a pack-horse trail and an even earlier track, the bridge over the river here originally being called (St) Stephen's Bridge. The large house on the left was the Valley Inn, originally the Clothier's Arms. It was once a clothier's house. Almost obscured by the large tree in the centre is Tyler's Mill, demolished in 1933.

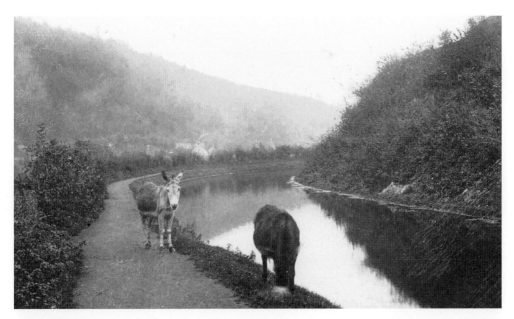

ABOVE VALLEY LOCK, pre-1914. Two workers out grazing for the night or playing truant? Donkeys were the animals used for towing barges and two were easily able to handle a 70-ton loaded barge.

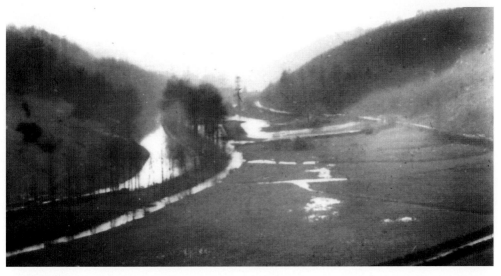

ASHMEADS, *c.* 1900-3, A view west from Frampton Farm in winter showing the flooded meadows and the canal sweeping round into Boultings Lock to the left. During the First World War, around 1917, the Old Hills Woods on the right were felled for pit props. The trees were dragged to the river bank where a temporary bridge was built across the river so that the cut-up trees could be loaded onto barges which turned in the pound below the lock. The barges took the pit props to near the Bourne boatyard (see page 73) where they were loaded onto railway wagons in the West Box sidings.

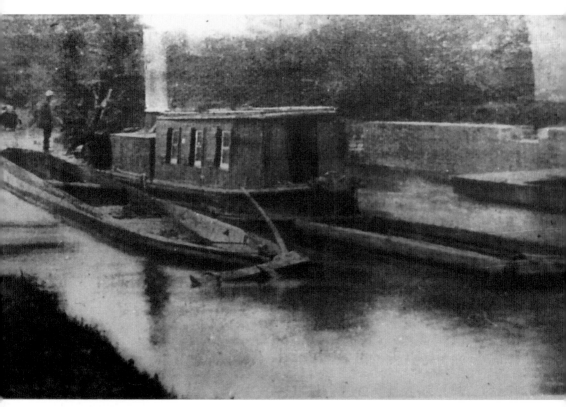

CHALFORD WATER WORKS, *c.* 1905-10. This shows the GCC steam dredger *Empress* at work alongside the Chalford Water Works Wharf. The barge in use as a mud boat is well down at the stern and has its tiller post laid horizontal, suggesting that the canal is very shallow. Another mud boat lies just beyond the dredger, probably waiting for the next load of mud. The water works was moved to Belvedere Mill (see page 76) around 1927, just before the abandonment of the canal. Chalford Water Works was midway between Valley Lock and Boultings Lock.

ABOVE BOULTINGS LOCK, *c.* 1895.

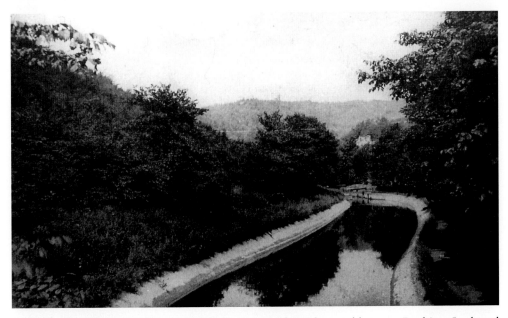

ABOVE BOULTINGS LOCK, *c.* 1900. Both pictures show the pond between Boultings Lock and Baker's Mill Lock before and after reconstruction by the Thames & Severn Canal Trust in 1897. The upper picture shows the probable state of the canal when de Salis carried out his survey for the Trust, and the lower picture shows how the problem of water leakage was overcome by concreting the complete bed. This section afterwards became known locally as the 'Conk'.

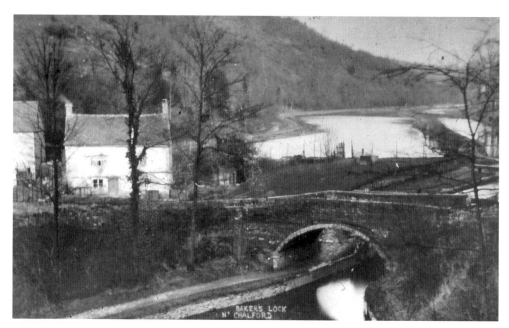

BAKER'S MILL, *c.* 1900. This view, east over Baker's Mill Bridge and Lock shows the canal reservoir in the background, which is now a private lake at Baker's Mill House. The reservoir was constructed by the Thames & Severn Canal Co. to guarantee a supply of water to the locks below. The reservoir was fed by the Frome as well as small streams from sources around Oakridge. Baker's Mill House is on the left with the end of the mill building at the extreme left. A small wharf above the lock was used to unload coal for Oakridge Mill, the coal being delivered to the mill by horse wagons and by donkey.

ABOVE BAKER'S MILL, *c.* 1910-14. The view from the towpath looking west towards Baker's Mill, with the canal to the left and the reservoir to the right. The houses on the left are Hattons and Little Hattons.

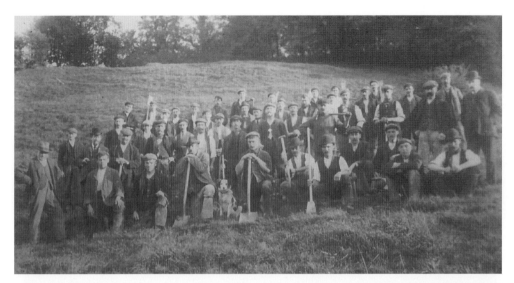

PUCK'S MILL, GCC work gang. These views are of the GCC restoration work being carried out to the canal and Puck's Mill Lower Lock in 1907. The work was necessary to try to cure the serious leakages from the pound between the two locks. The pictures probably show a very similar scene to those occurring when the canal was first cut. Note the great wealth of details to be seen in these pictures, such as the clay wagons on a tramway and the method of re-puddling the pound section by section; the portable forge and bench to repair ironwork on the gates; the size of the workforce necessary to carry out such a reconstruction, and the hand tools used by that workforce.

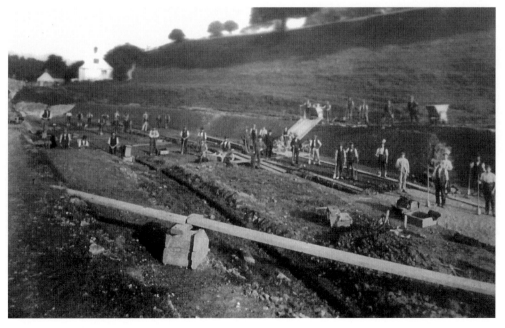

PUCK'S MILL POUND, looking east towards the Oak.

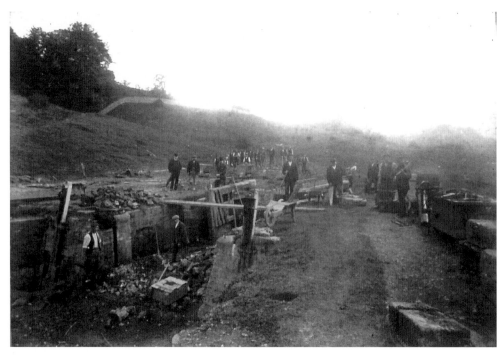

PUCK'S MILL, Lower Lock.

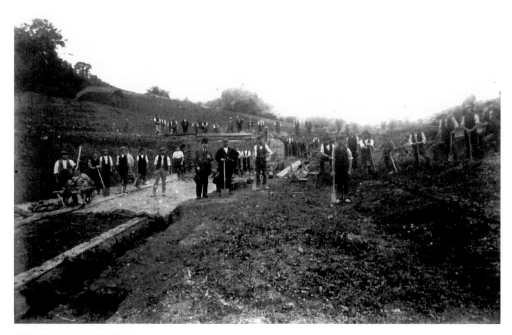

PUCK'S MILL POUND, looking west.

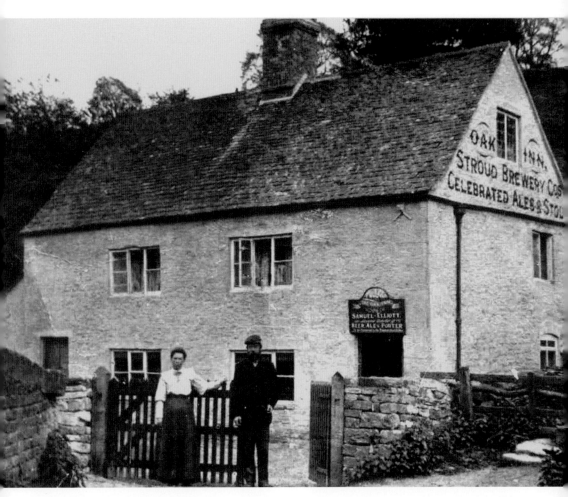

OAK INN, *c.* 1920. This was the only canalside inn between Chalford and Daneway and it was adjacent to Puck's Mill Bridge. Mr Samuel amd Mrs Emily Elliott were the landlord and landlady and can be seen at the gate. After closure (1922) the building was used as part of Puck's Mill Farm but is now restored as a modern house.

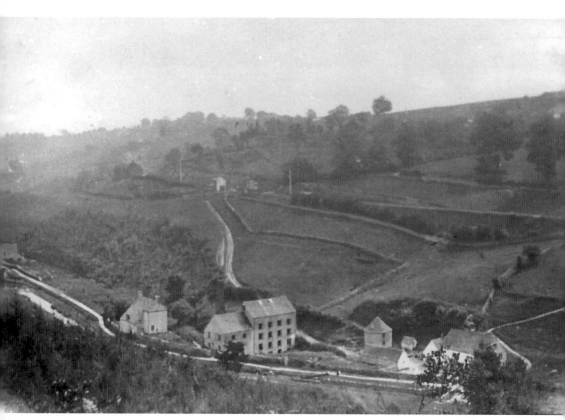

PUCK'S MILL AREA, *c.* 1900-12. Looking down on Puck's Mill from the valley side below Oakridge. Buildings from right to left are the Oak Inn, the round teasel-drying house, the derelict Puck's Mill and the mill house. Between the mill and round house, a rough track ascends the hill to Frampton signal box, the railway crossing and keeper's cottage, and thence to Frampton Mansell village. The railway tunnel entrance is roughly in line with the mill house. The mill was purchased by the Canal Co. to safeguard the water supply to its Baker's Mill reservoir. It was a woollen mill and it is believed that the machinery from the mill was transferred to Oakridge Silk Mill when the latter was built *c.* 1840.

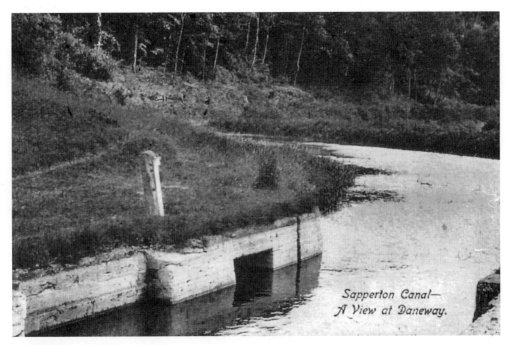

WHITEHALL LOWER LOCK, *c.* 1908-12. Above the top of the lock the canal turns to the left in an elongated arc to avoid the river which meanders through the meadows on the right. These meadows flood very easily and would have been a hazard to the canal.

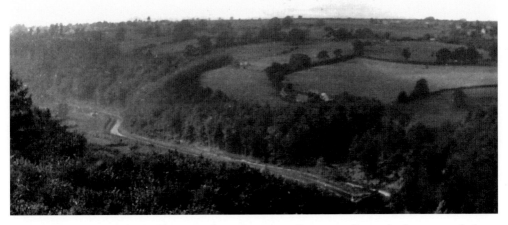

WHITEHALL, *c.* 1908-12. The view from Frampton Common shows the long pound above Whitehall Lower Lock. After the turn to avoid the river the canal straightens to run up to Whitehall Bridge at the right foreground. The houses above the trees are the Trillies on the lane leading from Whitehall Bridge to Far Oakridge, up on the right skyline.

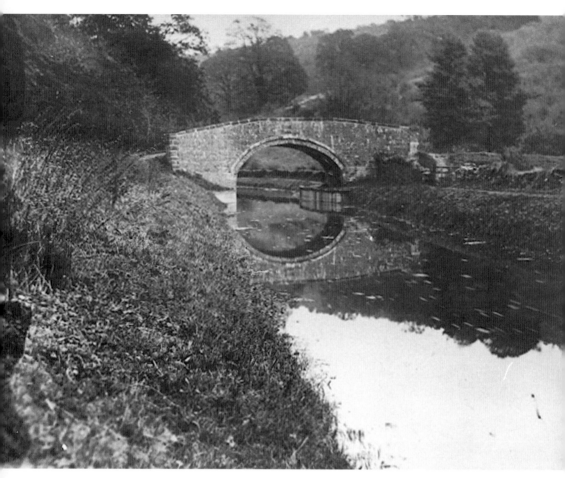

WHITEHALL BRIDGE, *c.* 1900-10. An accommodation bridge to take the lane from Far Oakridge down across the canal to Frampton Mansell and Daneway. It is a brick and stone bridge and on this west-facing side of the picture there is a date stone carved 'W.D. 1784'. Beyond this bridge to the east it was chosen to abandon the canal in 1927, while the canal to the west was not finally abandoned until 1933.

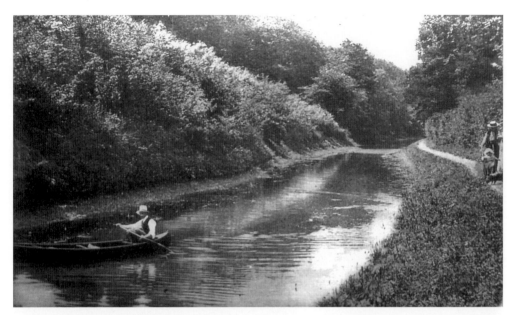

ABOVE WHITEHALL BRIDGE, pre-1915. While father enjoys himself in the canoe, mother and child watch from the towpath as the photograph is taken from the bridge. The banks show the water to be low in this pound but it is probably high summer. It is a nostalgic scene which, with effort, could again become reality.

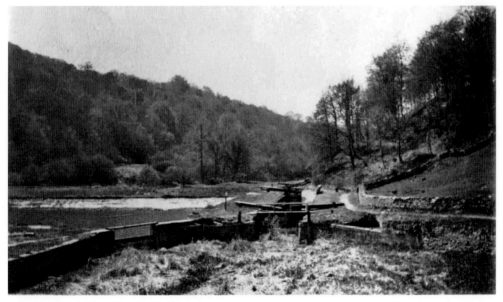

DANEWAY WHARF LOCK AND BASIN, 1917. A dry canal, lock and basin showing a condition which could be quite common even in the working life of the canal. In winter this section would probably have been full of water. On the left, with a footplank across, is the entrance to Daneway Basin where barges could unload so that they did not restrict canal passage.

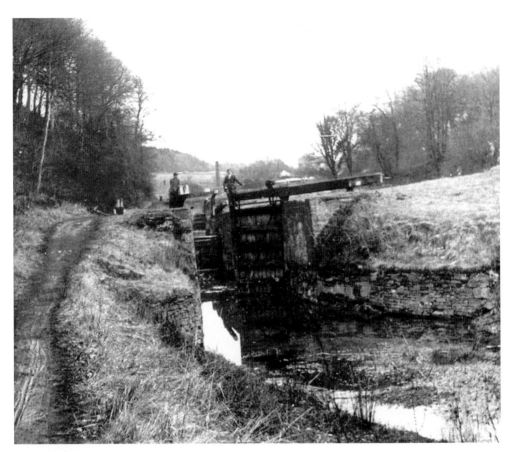

DANEWAY WHARF LOCK, pre-1915. This is believed to be the Daneway Wharf Lock or Basin Lock and not one of those further down the flight of locks leading up to Daneway. In the distance can be seen the chimney of Daneway Saw Mills, and also the Bricklayer's Arms. Note that the brick edging on the right has collapsed close to the entrance to the canal of the overspill water from the Daneway Basin.

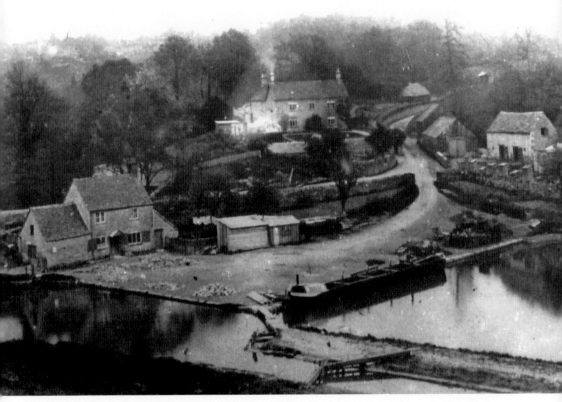

DANEWAY WHARF AND BASIN, *c.* 1905. The barge appears to have unloaded and so is probably waiting to return to the west. Piles of stone are by the cottage and coal lies in front of the barge on the wharf. Daneway Saw Mills lie behind the Wharf Cottage and the tall chimney almost blends in with the trees. The proprietor, Mr Gardiner, lived in the large house at the foot of Daneway Hill and his son Edward became a skilled chair-maker through the teaching and influence of Ernest Gimson. He later made chairs for Ernest Gimson and Sidney Barnsley of Daneway House and their craftsmen on a 50:50 profit basis. The road up Daneway Hill was built as a service road during the construction of the canal and later used to transport goods out of Daneway Basin when the canal was open to this point, but before the tunnel was open for navigation.

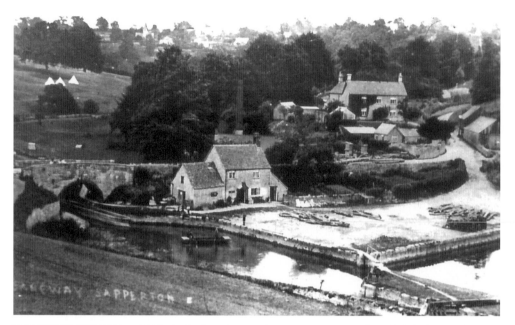

DANEWAY WHARF, *c.* 1910. A similar view to the previous picture but slightly later. The start of the Summit Lock chamber can be seen through the arch of Daneway Basin Bridge and the fact that a barge can be moored there almost surely shows that navigation of the summit level has ceased.

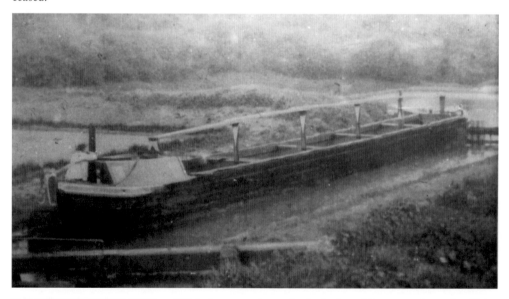

DANEWAY WHARF LOCK, *c.* 1905. An empty barge in the lock waiting to go down the flight. Until the First World War, Smart's barges were quite regular visitors to Daneway Basin with coal, tar, oil and stone, usually returning empty or with odd loads of timber, peasticks or faggots of wood. Over the bows of the barge can be seen the side ponds of the locks further down the flight.

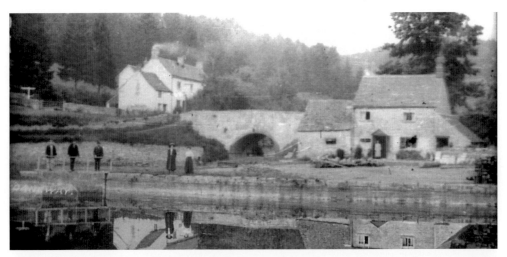

DANEWAY WHARF, *c.* 1895-1900. An idyllic scene looking across the basin, but actually posed for the photographer. The right-hand girl on the wharf is Annie Hyett of Weston, Bath, who had relatives at Chalford called Davis. Thus she was probably staying with them and it is possible that the others may be members of that family. Annie was born in 1874, hence the date for the picture. She married a Butt whose mother had been a Minchinhampton girl. Note that the lady in the Wharf Cottage doorway is wearing a man's cap, typical headgear for village women at this period.

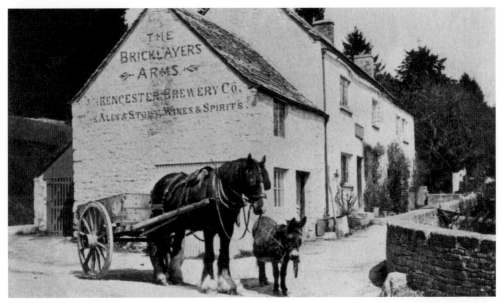

THE BRICKLAYER'S ARMS, 1917. Now, of course, the Daneway Inn, but originally built by the canal contractor, John Nock, in 1784 as accommodation for his men working in the tunnel. It was sold by the company in 1807 and became an inn which it has remained ever since. Note that at this time it was a Cirencester Brewery house. For almost a century a man-trap has hung on the wall in the bar.

SUMMIT LOCK, 1917. The canal is empty with little water in the summit level. This lock chamber is now infilled and the area serves as the car park for the Daneway Inn. It is quite probable that the chamber remains one of the best-protected because of this.

SUMMIT LEVEL, *c.* 1910-14. This view is looking west towards the Summit Lock. There is very low water and the towpath on the left is overgrown, showing that all navigation here has ceased.

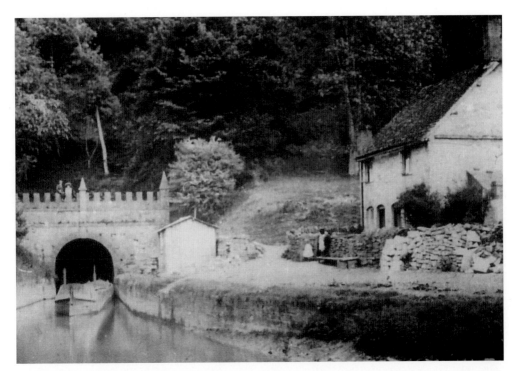

THE SAPPERTON TUNNEL PORTAL, 1900. The design of the portal was Gothic with battlements and finials as decoration. To the right is the lengthsman's cottage, based here to control navigation of the tunnel as the most important of his duties. The picture was taken just after the restoration work carried out by the Thames & Severn Canal Trust. A barge lies in the tunnel mouth and it appears to be going east through the tunnel. The shed by the tunnel is from the repair period and used to store tools, etc. Note the steeply rising bank into which the tunnel enters. In fact, the land rises some 240 ft above the canal level which is itself 365 ft above sea level.

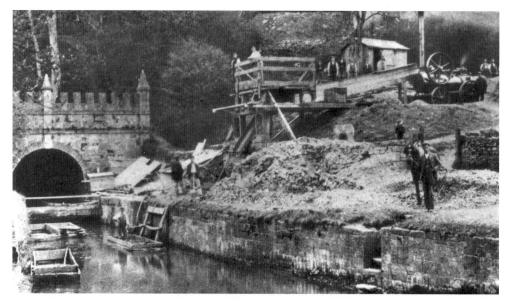

REPAIRS TO TUNNEL, July 1903. A view of the extensive working to repair the interior of the tunnel. It appears that small mud boats are being used to transport clay into the tunnel. The portable engine is driving a clay chopper and is the same outfit that was used in the clay pit at Bluehouse for the reconstruction there (see page 121). The shed seen in the previous picture has now been moved up behind the engine.

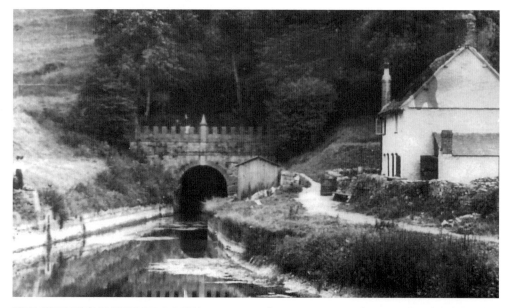

THE SAPPERTON TUNNEL PORTAL, c. 1910. The restoration work is completed and the shed returned to its original position to serve in later years as a chicken house for those living in the cottage. Compare this picture with the first of this western portal and note the alterations to the lengthsman's cottage and also the onset of dereliction of the canal.

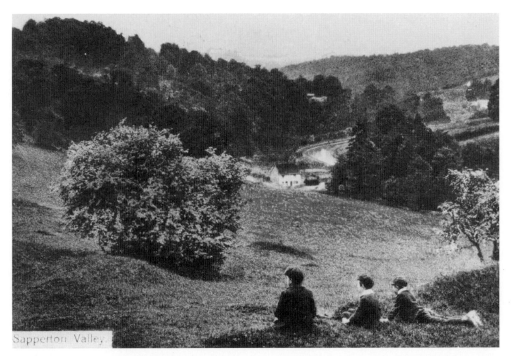

SAPPERTON VALLEY, pre-1915. Looking down into the valley from the fields below Sapperton Church towards the lengthsman's cottage by the tunnel entrance. The canal can be seen twisting away down the valley towards Daneway.

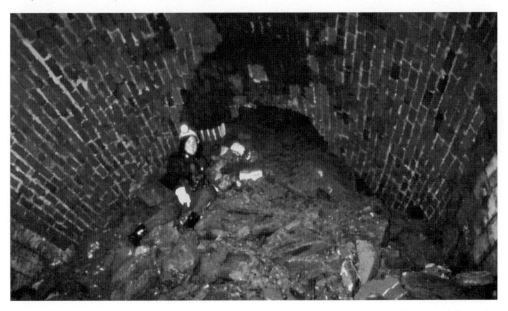

MAIN BLOCKAGE IN TUNNEL, 1967. At approximately 300 yards into the tunnel from the Sapperton end, the brick roof arch has collapsed and allowed the unstable Fullers Earth, through which the tunnel passes here, to completely block the tunnel for a distance of about 100 yards.

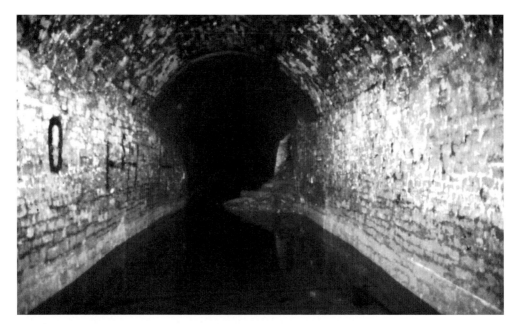

INSIDE TUNNEL, 1967. After passing through the Fullers Earth the tunnel approaches the Inferior Oolite at about 400 yards from the Sapperton end. Small bulges and breaches in the brick wall can be seen. The marks on the wall indicate the underwater positions of wooden strengthening timbers.

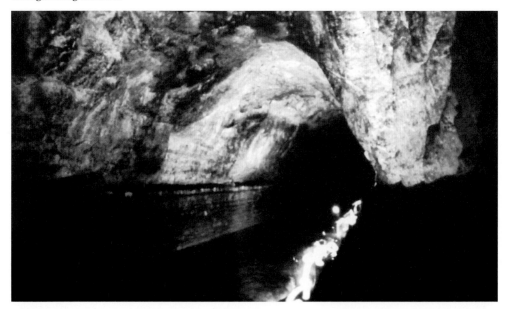

THE TUNNEL IN THE INFERIOR OOLITE. 1967. A length of about 900 yards of the tunnel is built through a band of Inferior Oolite limestone of sufficient strength not to need lining. The sides were lined to retain the clay puddle, and the area to the right was known as the legendary Peglers Wharf.

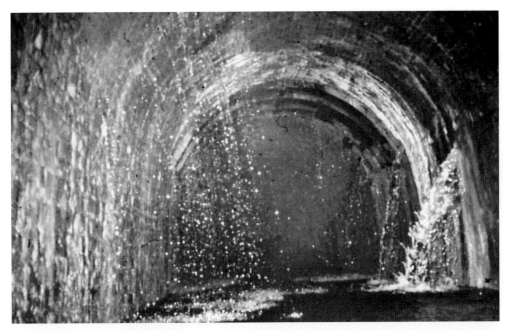

THE TUNNEL AT THE CASSEY WELL FAULT, 1967. Once through the Inferior Oolite, the tunnel passes through a faultline and back into Fullers Earth again. Large springs flow down the fault and through the roof and sides of the bricked tunnel. A timber framework was fitted against the curved roof to deflect the water down the sides and away from passing barges.

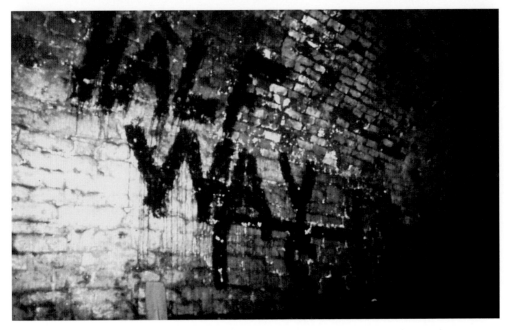

HALF-WAY THROUGH THE TUNNEL, 1967. This is about 1,900 yards in from either entrance in the long, brick-lined section through the Fullers Earth known as the Long Arching.

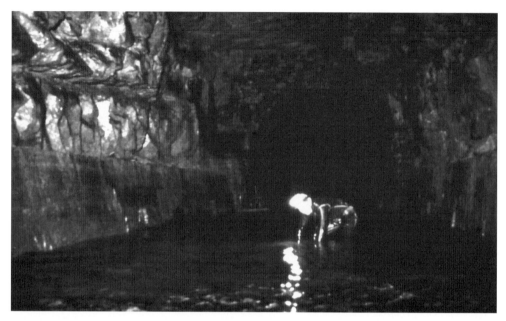

THE TUNNEL IN THE GREAT OOLITE, 1967. At about 2,700 yards the tunnel passed through a second faultline, from the Fullers Earth into the Great Oolite limestone. This was of sufficient strength to be left unlined with just the sides lined with stone. There are some large caverns caused by blasting with gunpowder.

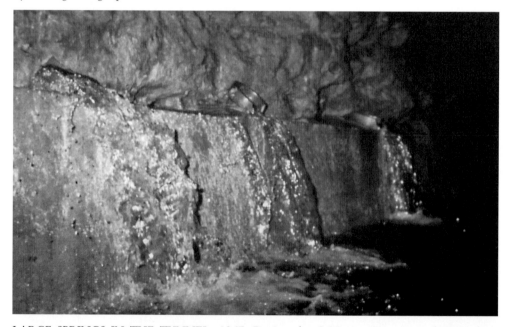

LARGE SPRINGS IN THE TUNNEL, 1967. During the GCC reconstruction of 1904 these springs in the Great Oolite were channelled in glazed pipes behind the newly concreted side walls to prevent them causing damage to the tunnel lining.

Thames and Severn Canal Navigation.

By an Act passed 23. G. III. f. 30. it is enacted,

"THat if any Person or Persons shall wilfully, maliciously, and to the Prejudice of the
" said Navigation, break, throw down, damage, or destroy, any Banks or other Works
" to be erected and made by Virtue of this Act, or do any other wilful Hurt or Mischief, to
" obstruct, hinder, or prevent the carrying on, compleating, supporting, and maintaining, the
" said intended Navigation, such Person or Persons shall be adjudged guilty of Felony; and
" every such Felon shall be subject and liable to the like Pains and Penalties as in Cases of
" Felony; and the Court by and before whom such Person or Persons shall be tried and
" convicted, shall and hereby have Power and Authority to transport such Felon, or award
" such Sentence as the Law directs in Cases of petty Larceny, as to such Court shall seem fitting."

BYE-LAWS and ORDERS

Passed by the Company constituted by the aforesaid Act.

ORdered, That all Boats passing the five Locks below the Summit-Pond, below Daneway-Bridge, shall observe the following Orders, viz.

So soon as Boats have observed the Hours of passing the Tunnel to the Sapperton End, and the Time is expired for the Boats to draw up, the first Boat shall draw into the Chamber of the upper Lock at Daneway-Bridge, and the Lashers of the lower Gates drawn to let her descend, observing at the same Time to draw the upper Lashers of the second Lock, to fill the Chamber of the said Lock, and at the same Time the first Boat waiting below the fifth Lock, below Daneway-Bridge, shall draw into the Chamber of the said Lock, and ascend, leaving the said Lock-Chamber full, for the Use of the first descending Boat; and then both Boats, ascending and descending, proceed until they meet. So soon as the said Boats have met, the second descending Boat above the uppermost Lock shall move down, to meet the first ascending Boat; and also, after the first descending Boat shall have passed the fifth Lock, the second ascending Boat shall proceed, &c. It being the Intent and Meaning of this Order, to make one Lock of Water serve the passing of two Boats, one ascending and one descending, under the Penalty of Three Pounds.

That the same Regulation be observed in passing the four Locks at Siddington, the Watchman noticing the Time for Boats arriving at Siddington from the Tunnel, to begin passing such Boats.

That Boatmen, with Boats passing thro' the Tunnel, must notice and comply with the following Orders, viz.

Boats to enter the Tunnel

At the Sapperton End, at 6 o'Clock in the Morning,
2 Ditto in the Afternoon,
10 Ditto at Night.
At the Coats-Field End, at 2 Ditto } in the Morning,
10 Ditto }
6 Ditto in the Afternoon.

The first Boat lying below the fifth Lock, below Daneway-Bridge, shall begin to move at 5 o'Clock every Morning, and the Boats going down the said five Locks move in their Turn. And if any Boat enter the Tunnel at any other Time than above mentioned, or is longer than four Hours in passing the Tunnel, and by that Means meets another Boat which has entered at the regular Time, such Boat exceeding the limited Time shall be taken back to the End of the Tunnel she entered at. And if any Boatman is found to use Shafts, or Sticks, or other Things, against the Arch of the Tunnel, in passing thro', in either Case the Steerer, or Person having the care of such Boat, shall forfeit and pay for every Offence the Sum of Five Pounds.

That no Shaft or Pole be used to push a Boat forward, but what has a Knob of Wood affixed to the End of it, of five Inches Diameter, and that no Shaft shod with Iron, or with a cross Bar of Wood at one End, or any Rope or Line wrapped or twisted round a Shaft or Pole, to stop or turn a Boat, be used upon this Navigation, between Brimscomb-Port and Inglesham-Lock, or upon the Collateral Cut, under a Penalty of Three Pounds, to be paid by the Steerer or Person having the Care of the Boat.

That the upper Gates of the Locks be always kept shut when the Chamber of the Lock is full of Water, under the Penalty of Forty Shillings.

That every empty Boat, passing upon the Canal, shall give Way to every loaded Boat, until the loaded Boat hath cleared the empty Boat; and that every loaded Boat going from Cirencester or Siddington, in each Line of the Canal, shall give Way, in Manner as aforesaid, to every loaded Boat coming towards Cirencester and Siddington, upon Pain that the Master of such Boat, for every Offence, shall forfeit the Sum of Forty Shillings.

That no Boatman be permitted to steer more than one Boat at a Time, or have any other Boat in Tow; nor shall any Person under eighteen Years of Age, attempt to steer or take the Management of any Boat, or use the Locks upon this Navigation, under the Penalty for every Offence, against the Owner of the Boat, of Ten Shillings.

That no Boat shall be navigated upon this Canal with the Stern foremost, or without a Rudder at the Stern; nor shall any Boat, whether loaded or unloaded, be haled along the Canal without a Person at the Helm to guide the same; nor without the haling Line being affixed to the Mast, to prevent the Boat running or beating against Bridges, Banks, or other Works of the Canal; nor shall any Boat, or Vessel, pass upon this Canal with less Lading than 20 Tons, unless such Boat shall have a false Rudder hung to the lower Part of her real Rudder, of at least four Feet long, and 18 Inches deep, to be affixed and used at all Times, when any such Boat shall have less Lading than 20 Tons on Board; and for every Offence against this Order, the Master of such Boat shall forfeit the Sum of Twenty Shillings.

That every Boat shall stop at a Post to be fixed 40 Yards distant from every Lock, and from thence be gently shafted into the Lock; and every Master of a Boat, or Vessel, shall, before he opens the Gates of any Lock, examine the Paddles, and see that the Lock is fit to receive the Boat; and in moving the Boat into the Chamber of the Lock, the Master of the Boat shall be provided with a Piece of Wood, or Lever, which he shall put between the Lock-wall and the Boat Side, to prevent the Boat striking the Lock Gates; and for every Offence against this Order, shall forfeit the Sum of Forty Shillings.

CIRENCESTER: PRINTED BY S. RUDDER. 1792.

COMPANY BYE-LAWS AND ORDERS, 1792. These orders are mostly concerned with the process and times for navigating the tunnel, but they also lay down the stiff monetary penalties for other offences of which wilful damage could ultimately lead to transportation.

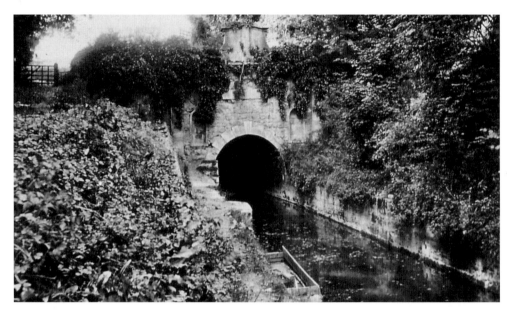

THE COATES TUNNEL PORTAL, *c.* 1900. This eastern entrance was of a classical design with columns, niches and tablet. There was no towpath through the tunnel and barges were legged or pushed along. The horses or donkeys used for towing would have crossed the summit through the woods, coming back onto the towpath through the small gate at the top left. A small maintenance punt can be seen in the canal.

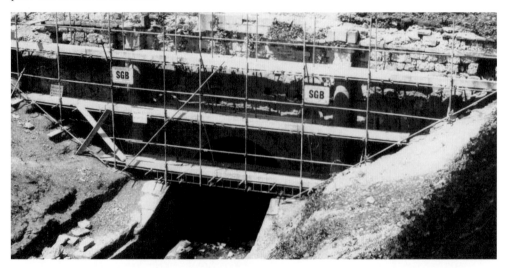

COATES TUNNEL PORTAL RESTORATION, 1976. After some 180 years it was found that the stonework was being gradually pushed forward and was in danger of collapsing. Restoration by the Trust involved removing the complete façade and rebuilding it by fixing it securely to the ground behind, and replacing the stone that had deteriorated severely over the years since its construction in 1789. It proved a costly operation, the work being carried out by Bruce Russell, a local professional stone mason.

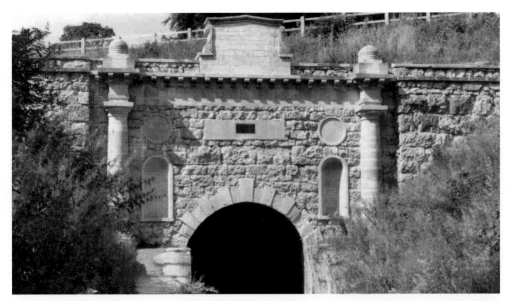

THE RESTORED COATES TUNNEL PORTAL, 1979. Shown here is the completely rebuilt portal with new stonework and tablet. The work carried out here represented a great achievement for the Stroudwater Thames & Severn Canal Trust who were the forerunners to the Cotswold Canals Trust. On 23 July 1977 an official reopening ceremony was performed by Lord Bathurst and a fête was also held in front of the Tunnel House to celebrate the occasion.

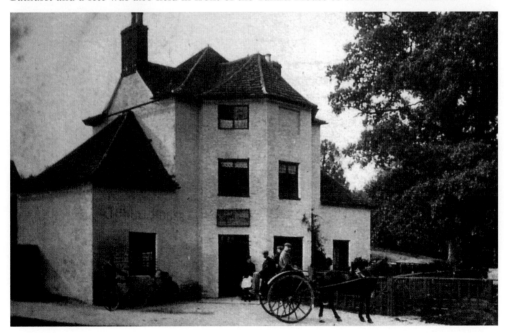

TUNNEL HOUSE, 1907. Originally called the New Inn but built primarily to serve the men working on the excavations of the tunnels. The building had rooms large enough to be considered as communal sleeping and dining areas. In the yard at the rear were large stables and sheds.

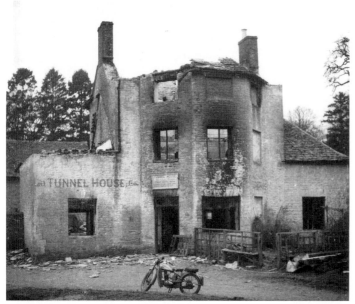

TUNNEL HOUSE FIRE, 1952. A disastrous fire in January gutted the whole building. It was subsequently rebuilt without its upper floor, with a different roof shape and with substantial internal alterations.

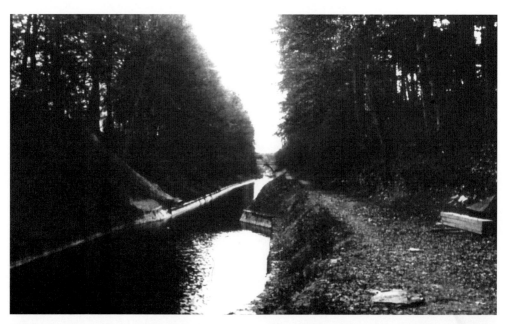

THE KING'S REACH, 1904. The view on emerging from the tunnel. The canal is in a deep cutting, named the King's Reach following a visit by George III in 1788. The canal is shown fully restored and is concreted down to Tarlton Bridge to stop leakage into the rock through which the cutting is made. Note the lay-by where barges would have awaited their turn to navigate the tunnel, and also the stop-planks. Stop-plank grooves occurred at regular intervals along the summit level. (GCRO)

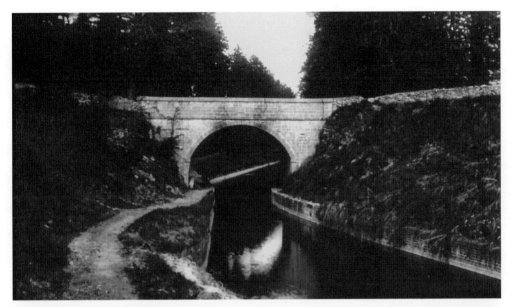

TARLTON BRIDGE, 1904. This bridge was built in 1823, possibly as a more permanent replacement for a wooden bridge. It has always been kept in good order for road access to Tarlton village. Note the smoke marks on the parapet, possibly showing the passage of steam barges, tugs or just the smoke from the cooking stoves of horse-drawn barges over the years. (GCRO)

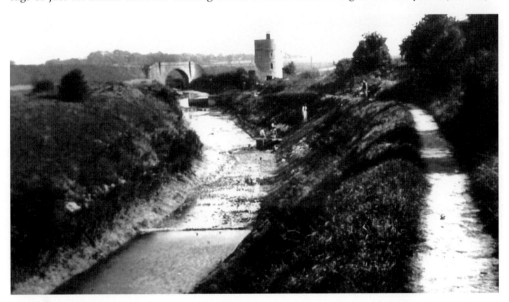

RESTORATION WORK AT COATES, 1902. The GCC work underway by Coates Round house. A section of canal bed has been planked off and is being re-puddled to try and stop the leakage into the rock. Repairs are also being made to the towpath bank. Note the round house and the waist with stop-planks, and in the background the high-arched skew bridge which carried the GWR line, opened in 1845, across the canal from Kemble to Stroud. (GCRO)

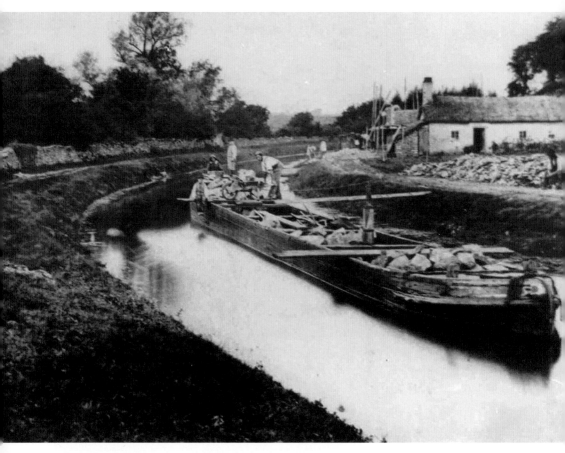

LOADING STONE AT COATESFIELD QUARRY, *c.* 1880. This shows a good working scene on the canal. There are very few such photographs along the eastern reaches of the canal, but here large blocks of stone are being loaded by wheelbarrow out of the quarry and across a plank onto the narrow boat.

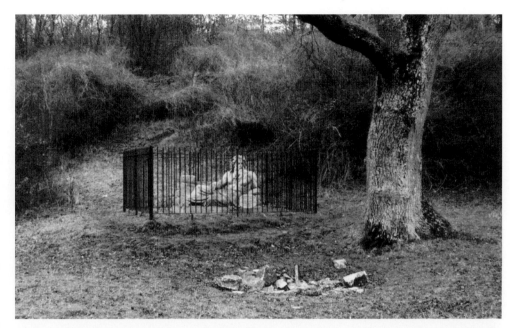

THE SOURCE OF THE RIVER THAMES, 1962. Close to the canal at Thames Head is the source of the River Thames. In wet winter conditions when the water-table rises, water comes from the spring shown here marked by the stones by the ash tree. The statue of Father Thames was a decorative piece from the Crystal Palace in London and was eventually placed here in 1957 to mark the source of the river. It became badly vandalised and was replaced by a stone plaque and re-sited at St John's Lock at Lechlade. The canal was purposely built on the valley slope to avoid the winter floods that still occur here.

THAMES HEAD BRIDGE, 1950. The Fosse Way crossed the canal at Thames Head Bridge close by the wharf and made a sharp turn to the west. This special corner-post was fixed to the arch under the bridge and shows testimony to the many tow-ropes that have pulled barges round the corner. The bridge is now almost buried by the realigned road.

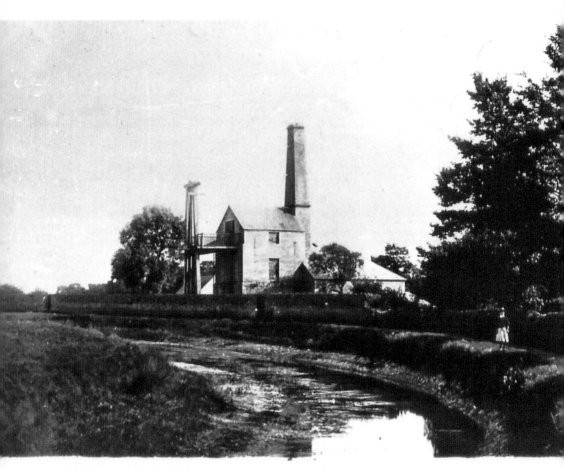

THAMES HEAD PUMPING STATION, *c.* 1905. This picture by Henry Taunt, the Oxford photographer, was described by him as showing the engine 'at work' and water ripples can be seen coming towards the camera position. Once the company had chosen Thames Head as the site for a well to supply water to the canal, it first established a windmill pump which was quickly superseded by a Boulton & Watt engine and pump in 1794. This engine lasted for sixty years until worn out and was then quickly replaced by a Cornish mining engine with new boilers and pumpwork. This engine was of much greater efficiency in many ways. The last water was pumped into the canal in 1912 when the engine was greased down and virtually mothballed. The engine outlasted the abandonment of the canal in 1927 and was eventually sacrificed as scrap metal during the last war in 1941 when the engine house was also demolished.

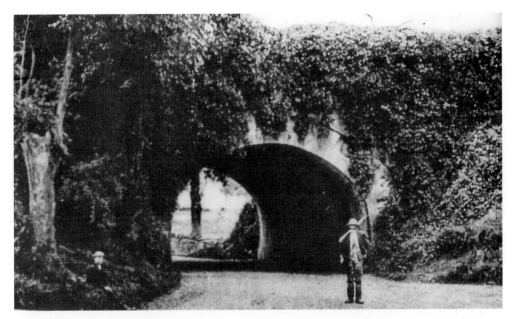

SMERRILL BRIDGE, 1914. The summit level followed the 365 ft contour and an aqueduct was constructed at Smerrill over the Cirencester to Kemble road. The embankments either side were revetted with dry-stone walling and they culminated in a single arch over the road. Soon after abandonment in 1927, it was demolished.

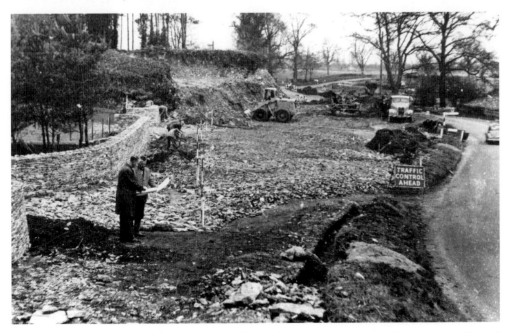

SMERRILL, 1960. The old sharp corner in the road underneath the aqueduct was straightened out. This involved cutting back the canal embankments which showed it to be composed of rubble stone which is conveniently being relaid as hardcore for the new road.

SMERRILL EMBANKMENT, *c*. 1960. This cross-sectional view shows the rubble, stone construction and the clay lining in the profile. In the foreground are the few remaining courses of masonry from the old arch of the aqueduct.

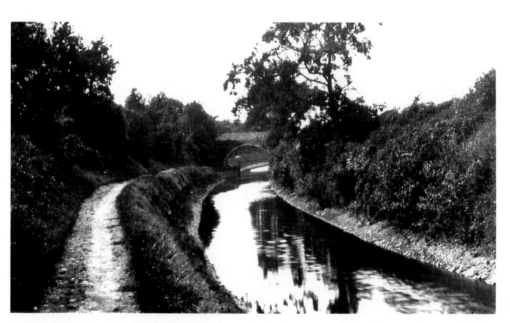

LEVEL BRIDGE, 1904. This bridge, just west of Bluehouse, is so called because the canal is in a small cutting and it does not need a hump back.

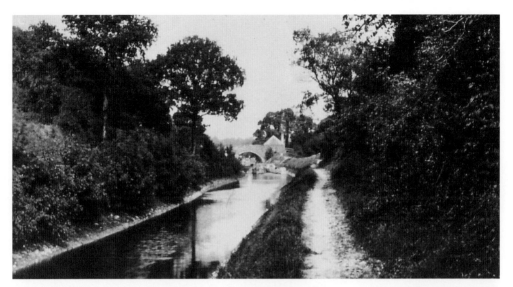

RESTORATION WORK AT BLUEHOUSE, 1902. The GCC restoration gang had reached Bluehouse on the summit level by 1902 and it was found necessary to reconstruct the canal bed to try to prevent water leakage. In the distance can be seen Bluehouse or Furzen Leaze Bridge, the lengthsman's cottage and the maintenance barges in the canal.

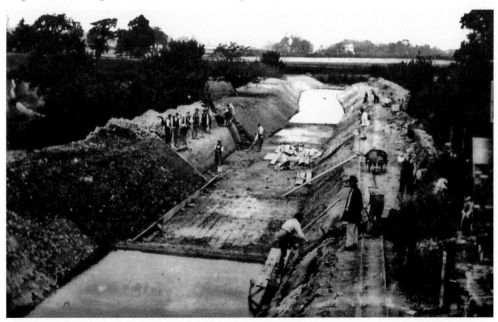

RESTORATION WORK AT BLUEHOUSE, 1902. This picture, probably taken at the same time as the previous one, shows the whole scene of the construction. A narrow gauge rail track has been laid for tubs carrying the clay from the claypit which was back to the left off the picture. The work gang is re-puddling the canal bed and banks between two sets of planks holding back the water. (GCRO)

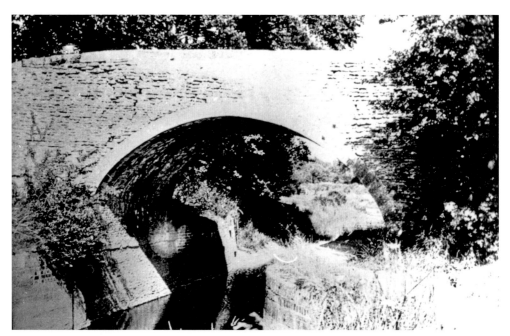

MINETY ROAD BRIDGE, *c.* 1925. A stone-built bridge typical of many that carried small roads across the canal.

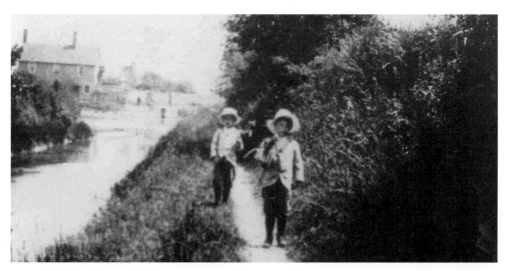

SIDDINGTON JUNCTION, *c.* 1925. The branch line to Cirencester joined the main line of the canal to the left of this picture. The branch line was 1¼ miles long and apart from joining Cirencester to the canal system it was also used to bring the main supply of water to the summit level from the River Churn. Siddington was also the headquarters of the eastern section of the canal and the Clerk of the Works was based here at the small wharf and maintenance depot. He was responsible for reporting back to the Brimscombe headquarters about conditions on the summit level and eastern traffic movements.

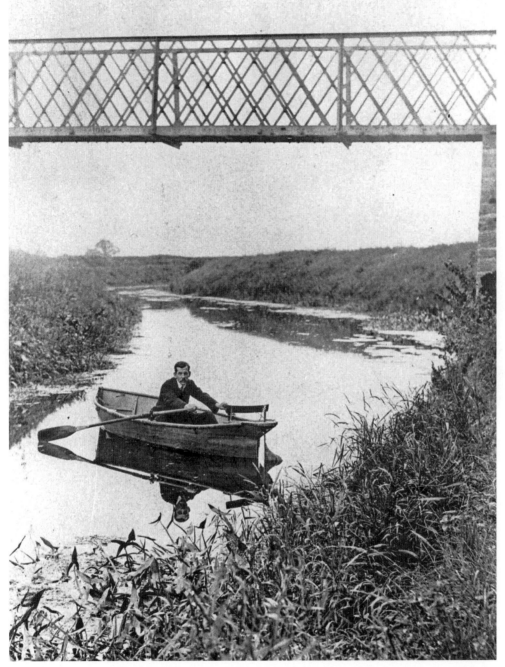

CIRENCESTER BRANCH FOOTPATH BRIDGE, *c.* 1910. Just south of Siddington rectory a footpath crossed the canal to give access to the National School. It was probably a high-level wooden bridge but was replaced by this iron girder bridge in 1906, the date being painted on the left-hand bottom girder.

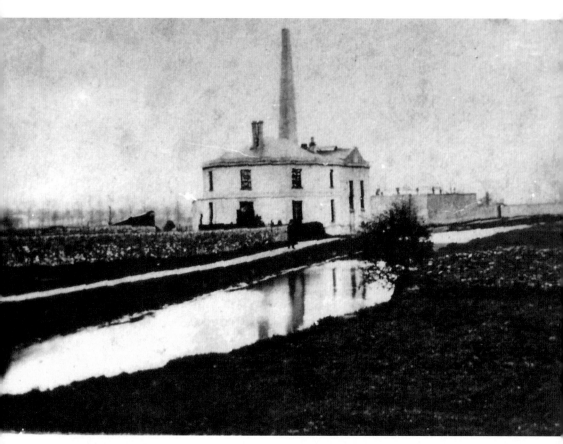

CIRENCESTER BRANCH BY THE GASWORKS, *c.* 1880. The gasworks was deliberately built by the side of the canal and had its own wharf on which to unload coal and supplies. With the opening of the Midland & South Western Junction Railway later in the decade, it is quite probable that the coal was then brought in more cheaply by rail.

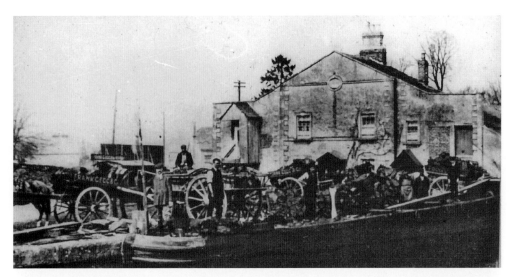

CIRENCESTER WHARF, 1904. Following the GCC restoration of the canal, on 19 March 1904 the narrow boat *Staunch*, belonging to Joseph Hewer, arrived at Cirencester Wharf with a cargo of 37 tons of coal for Frank Gegg & Co. The coal is shown being unloaded onto the carts standing on the wharf, and Frank Gegg is standing by the flagpole. Note the warehouse in the background which had accommodation for the agent in the centre, and warehousing to each side and rear. There were similar warehouses at Cricklade and Kempsford wharves.

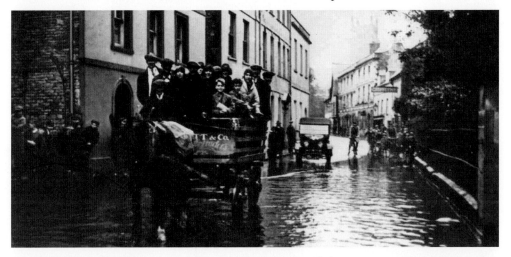

CIRENCESTER FLOODS, 1929. With the abandonment of the eastern section of the canal in 1927, the Cirencester Basin was filled in. The main canal feeder from the River Churn had entered the basin at Cirencester Wharf. Since the advent of the canal 150 years before, the bed of the river, downstream from the feeder take-off point, had been allowed to silt up. Thus, when in 1929 a prolonged spell of wet weather set in, the excess water in the river backed up, overflowed, and flooded the streets in the north of the town. Work was then given to the unemployed men to clear out the blocked river. Shown here are the floods in Dollar Street with a horse and cart in use to ferry people through the water.

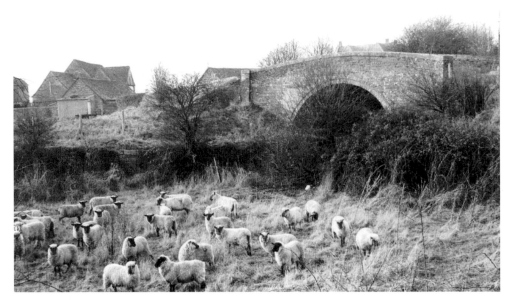

OVERTOWN OR UPPER SIDDINGTON BRIDGE, 1962. The canal dropped from the summit level through a flight of four locks very close together at Siddington. This bridge is over the tail of the Upper Lock. There were large, almost circular pounds between these locks to hold sufficient water to operate them. The sheep are grazing in the pound area between the Upper Lock and the Second Lock.

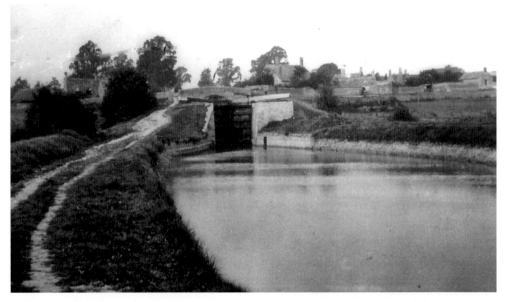

SIDDINGTON LOCKS, 1902. The canal is shown here as fully restored with Siddington Second Lock in the background. Beyond the bridge was the Upper (Summit) Lock with the junction of the Cirencester branch line going off to the right. The buildings to the right of the bridge were associated with the Siddington headquarters of the Eastern Section (see page 122). (GCRO)

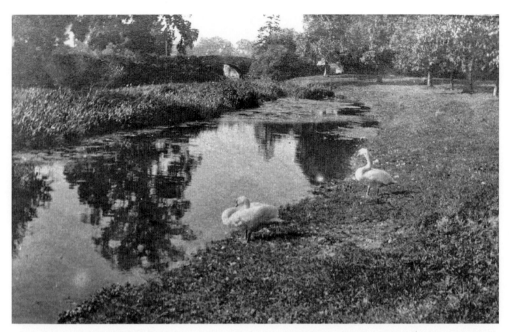

BELOW COWGROUND BRIDGE, *c.* 1920. Below the Siddington flight of locks the canal passed under the road to Ashton Keynes by the Greyhound public house, and is here shown sweeping through Plummer's Farm and into the water meadows alongside the River Churn.

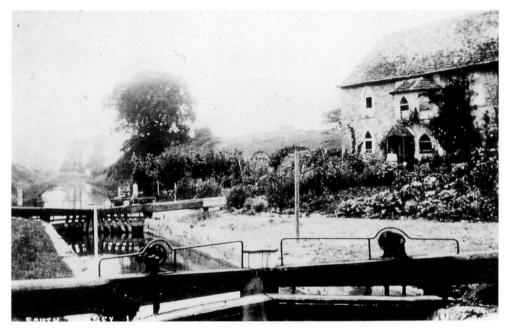

SOUTH CERNEY WHARF AND UPPER LOCK, *c.* 1910. At South Cerney there were three more locks close together. Shown here is the Upper Lock, the wharf and cottage. Trade at this isolated wharf was mainly coal, with bricks and agricultural produce going out.

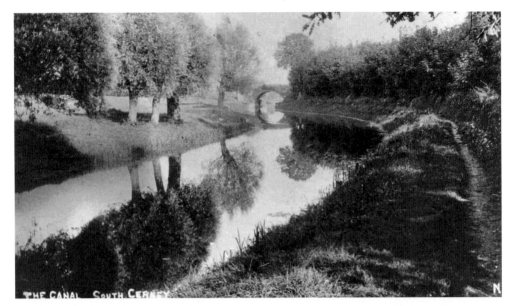

ABOVE CRANE BRIDGE, *c.* 1900. A scene portraying the beautiful rural isolation of this canal section as it tracks across country between South Cerney and Cerney Wick. One of the shortcomings of the canal was that, after Cirencester, it did not pass through or near to any significant centre of population which would have generated local traffic and demand for goods.

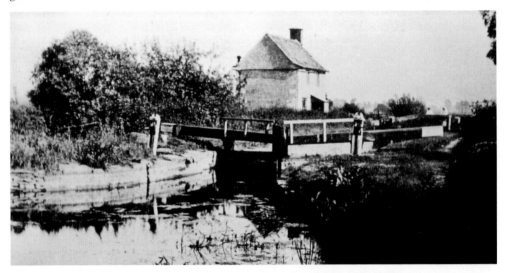

WILDMOORWAY LOCK AND COTTAGE, *c.* 1900. Originally this lock had a deep 11-ft fall and the pound above could not hold sufficient water for sustained operation. Consequently a side pond was built which held one-third of a lock-full of water. The cottage was built so that full control of this water system could be made by a lengthsman who was moved to here from Cerney Wick. Alas, the original cottage fell into bad disrepair and was demolished but a similar cottage was rebuilt on the same site some years ago.

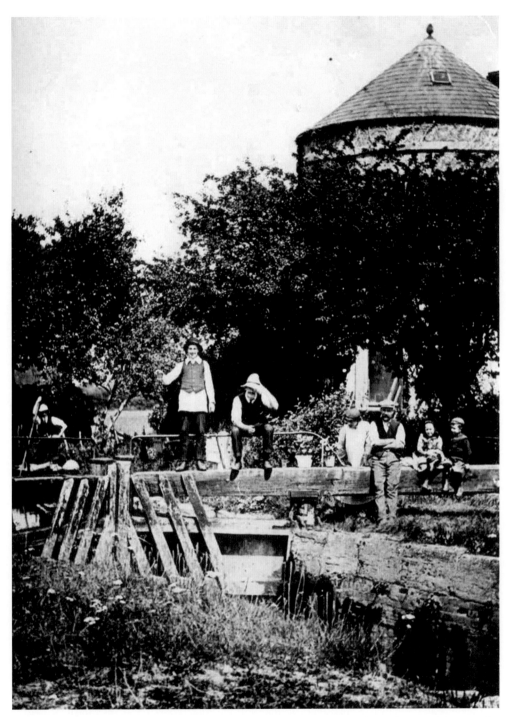

CERNEY WICK LOCK, *c.* 1930. A family scene but most probably from the round house. This is after abandonment but there does appear to be some water above the lock for the man to be in a punt.

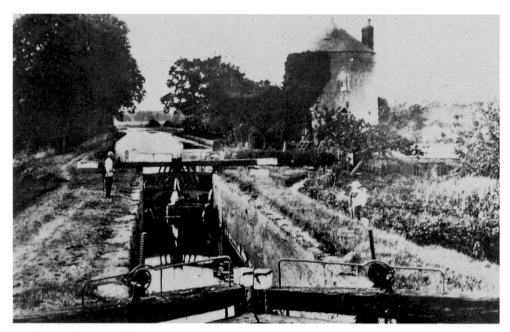

CERNEY WICK LOCK AND ROUND HOUSE, *c.* 1905. Of the five round houses along the canal, Cerney Wick and Chalford had pointed roofs, while Coates, Marston Meysey and Inglesham had inverted roofs. This picture was taken just after the GCC restoration. Note the new balance beams and the iron handrails across the gates.

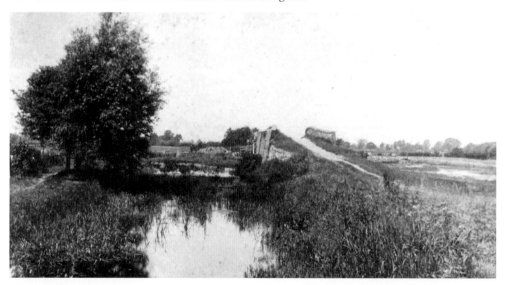

AT LATTON JUNCTION, *c.* 1895. The bridge carried the Thames & Severn Canal towpath over the link to the North Wilts Canal and the short aqueduct above the River Churn, at Latton Junction. The Thames & Severn Canal is on the right of the bridge, while in the foreground is the River Churn. In the background is the low stone aqueduct taking the link into the basin (see next picture).

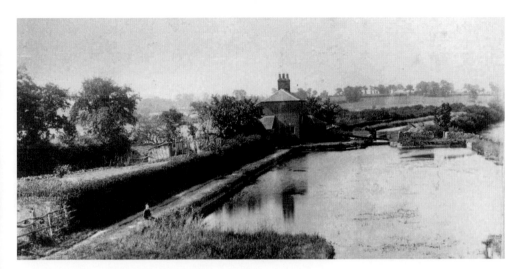

LATTON JUNCTION BASIN, *c.* 1895. This photo is taken from the bridge shown in the previous photo. In the foreground is the aqueduct over the River Churn leading into the rectangular stone-lined basin. In front of the Toll House is the North Wilts Canal leading out of the basin. Although the two canals met here and were on the same level, so jealously did each guard its water that two stop gates were built in front of the house, one in the control of each company. The small boy is Joe Howse, son of Mr Alfred Howse, lock-keeper at that time. The little porch at the front of the house was called 'the Office' where all canal business was transacted.

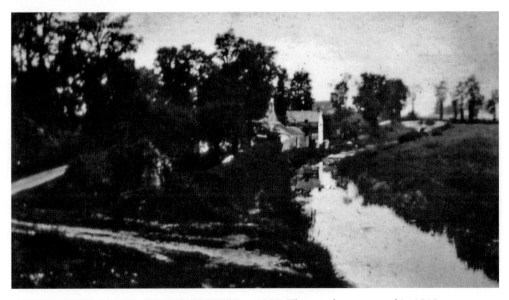

NORTH WILTS CANAL AT CHELWORTH, *c.* 1900. The canal was opened in 1819 as a narrow canal linking the Thames & Severn Canal with the Wilts & Berks Canal at Swindon. It was 9 miles long with eleven locks and enabled traffic to avoid the upper reaches of the River Thames between Abingdon and Inglesham where navigation could be impeded by low water. This photo shows Chelworth Wharf and the portal of the small Cricklade Tunnel in the distance.

Lacock Dec 3. 1885

Dear sir i write to inform you that we have been froze up ever since thursday night we left devizes on whenesday night and we had something to do to get off the chennet and aroncon we are got back on the wilts and berks canal we are about six miles from simmington they run the ice boat to calne yesterday and they are going to run it to simmington to morraw and then we shall be able to make another start towards home i have got five tons of sand and i paid for it has you ordered me to do so it was eighteen pence per ton and i had to pay the wharfage on it we shall try and get home as soon as we can dear sir please san send me thirty shillings in a postal order to wooten basset post office by return of post be sure and send by return so no more at present

i remain yours truly

Thomas Gardiner

BARGEMASTER'S LETTER, 1885. A letter from bargemaster Thomas Gardiner to his boss, James Smart of Chalford, telling him of his troubles with ice on the Kennet & Avon and Wilts & Berks Canals. He would then proceed, via the North Wilts Canal, on to the Thames & Severn at Latton to get back to Chalford.

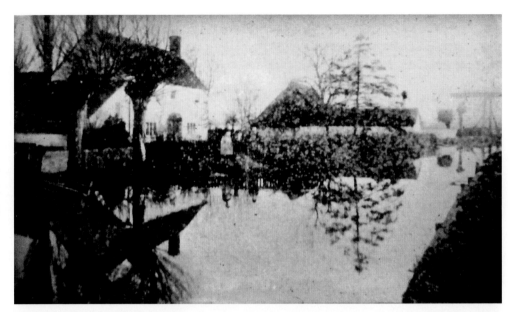

NORTH WILTS CANAL AT PRY, *c.* 1890. A poor-quality photo but it shows the canal at Pry Farm with the lifting bridge in the distance, about halfway to Swindon.

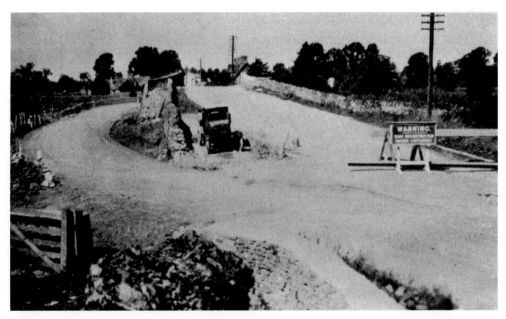

LATTON BRIDGE DEMOLITION, 1928. This bridge carried the main Cirencester to Swindon road (A419) over the canal just outside Latton village. As soon as the canal had been abandoned in 1927 permission was sought to demolish this bridge and get rid of the responsibility and the bottleneck to traffic that it caused. This photo shows a new temporary roadway *in situ* around the bridge while it was demolished.

CRICKLADE WHARF, *c.* 1920. A painting showing the Fairford Lane Bridge over the canal with haystacks on Cricklade Wharf to the left.

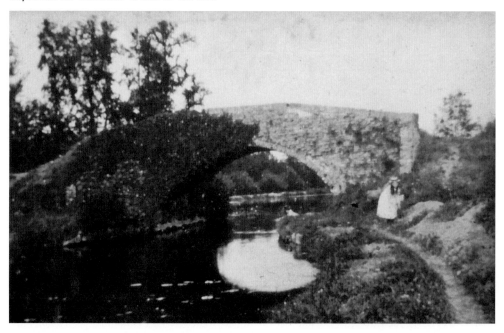

EISEY BRIDGE, 1901. A typical accommodation bridge built to give access across the canal to Eisey Farm. The canal is very isolated along this section with nothing between Cricklade Wharf and Marston Meysey Wharf except for two farms, a distance of about three miles.

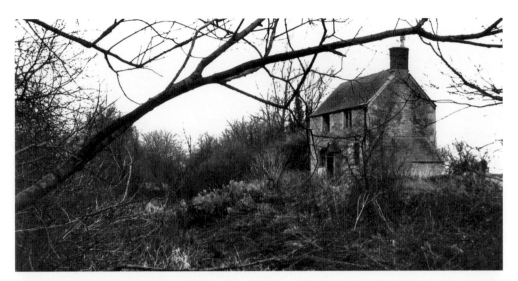

EISEY LOCK COTTAGE, 1962. The cottage was built in 1831 for the lengthsman who moved from Marston Mersey. It had the same layout as the cottage at Wildmoorway with two bedrooms, two living rooms and two stables/storage rooms underground in the canal bank, reached by steps at the far end. The canal bed in the foreground enters Eisey Lock just below the cottage.

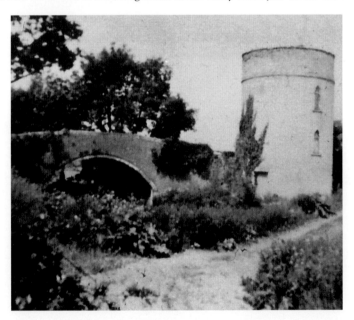

MARSTON MEYSEY WHARF AND ROUND HOUSE, 1960. One of the canal's isolated rural wharves situated about one mile from the village. The small amount of trade from here was mainly agricultural produce and the company saw fit to move the lengthsman from here up to Eisey Lock where at least some control over the use of the lock could be made. The picture shows the bridge and round house but all signs of the wharf have been lost and a farm track crosses the canal bed rather than use the bridge.

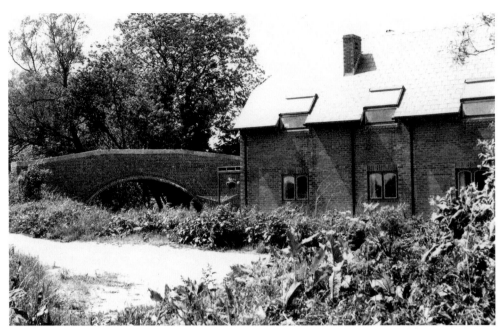

MARSTON MEYSEY, 1988. An equivalent view compares with the previous picture. The round house has been carefully restored but is hidden by the new extension development attached to it.

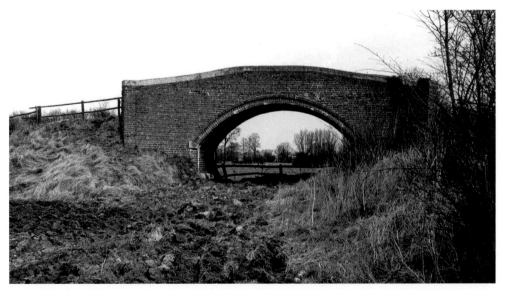

OATLANDS BRIDGE, 1966. A typical brick-built bridge over the canal to give access to a few fields which were cut off between the River Thames and the canal. After abandonment, when the land either side of the bridge was returned to agricultural use, the owner saw no good reason to demolish the bridge as all the other similar small accommodation bridges had been. Today, it remains isolated out in the fields with no hint of canal to either side.

OATLANDS BRIDGE, 1966. Details on this brick built into the parapet of the bridge show how bricks from the 'Stonehouse Brick & Tile Co. Ltd.' were brought along the canal during the GCC restoration of 1902 when this bridge was rebuilt.

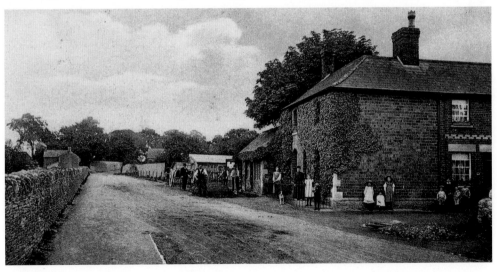

WHARF LANE, KEMPSFORD, 1914. Kempsford was the largest place along the canal between Cricklade and Lechlade. The wharf was important enough to have an agent's house/warehouse and it was here that the important Whelford Feeder entered the canal. Timber, stone, coal and agricultural products formed the basis of trade and this picture shows Wharf Lane to the right leading down to the wharf. The blacksmith's was an ordinary part of the village community and Kempsford Bridge can be seen in the background.

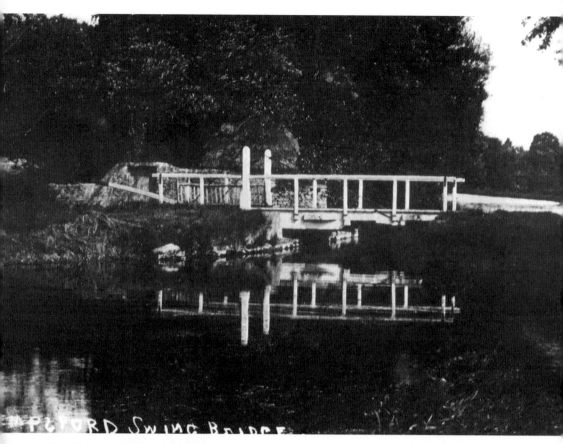

KEMPSFORD SWING BRIDGE, *c.* 1910. The swing bridge just above the village was typical of many along the canal, none of which remain, though few were ever photographed. The bridge gave access to small fields cut off between the River Thames and the canal.

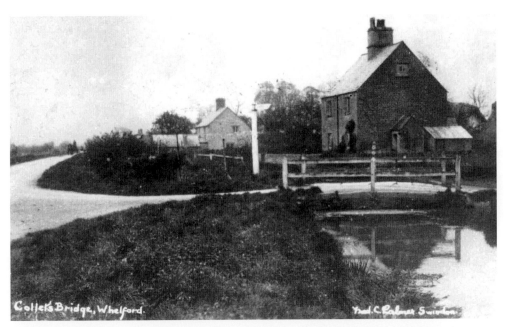

COLLET'S BRIDGE ON THE WHELFORD FEEDER, *c.* 1930. Construction of the feeder meant that many small bridges had to be made across it to the houses and for roads. Collet's Bridge is typical, showing how low down they were. The feeder was cleaned out regularly, not only to keep the water flowing, but also to attract fish along it from the River Coin at Whelford.

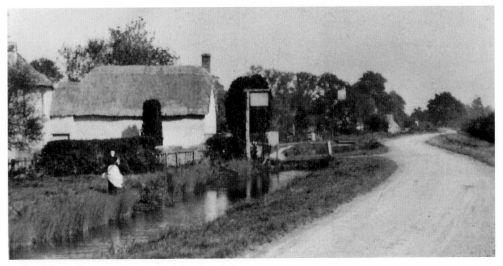

WHELFORD FEEDER, *c.* 1915. A canal feeder was built from below Whelford Mill to the canal at Kempsford in order to obtain sufficient water to operate the last three locks on the canal. The feeder followed the road out of Whelford and then cut across open fields and had a fall of only a few feet to the canal. It is seen here by the Queen's Head, where Florence Griffin was the last landlady for Simmond's Brewery from 1930 to 1954. It was then that the buildings were pulled down as they were in direct line of the new runway at RAF Fairford.

Lacock Dec 13. 1885

Dear sir i write to inform you
that we have been froze up
ever since thursday night we
left devizes on whenesday night
and we had something to do to
get off the chimet and aron con
we are got back on the wilts and
berks canal we are about six
miles from simmington they run
the ice boat to calne yesterday
and they are going to run it
to simmington to marrow

and then we shall be able to
make another start towards
home i have got five tons of
sand and i paid for it has
you ordered me to do so it was
eighteen pence per ton and i
had to pay the wharfage on it
we shall try and get home as
soon as we can dear sir please
oer send me thirty shillings
in a postal order to wooten
basset post office by return
of post be sure and send by

return so no more at presen
i remain yours truly

Thomas Gardiner

BARGEMASTER'S LETTER, 1885. This letter is from bargemaster W. Pearce (see page 18) back to his boss, Mr J. Smart of Chalford, to keep him informed of his progress through bad winter ice from Siddington to Inglesham, some three inches thick at Kempsford. Mr Pearce was *en route* to Oxford and proposed the alternative route via Abingdon and the Wilts & Berks Canal due to the high water in the River Thames restricting navigation upstream.

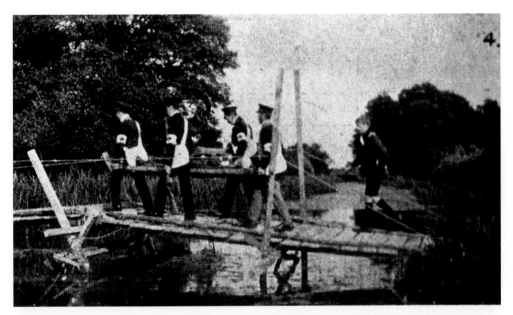

CANAL USED FOR RED CROSS PRACTICE, 1912. The Fairford Red Cross male detachment held a field day practice at Kempsford using the canal as an obstacle. A bridge had to be built across the water over which they then had to carry 'wounded' soldiers.

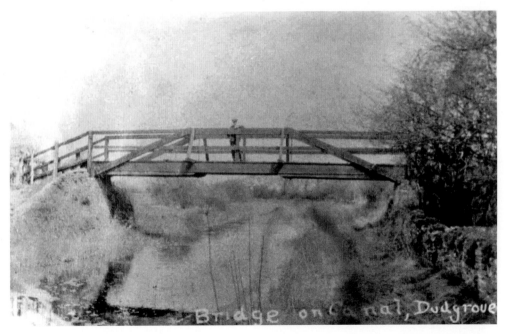

GREEN LANE OR WOODEN BRIDGE AT DUDGROVE, c. 1915. From Kempsford to Inglesham is just over three miles but the canal only touched upon one isolated settlement at Dudgrove Farm. Many tracks cross the countryside here and their rights of way were marked by such bridges as this one near Dudgrove.

DUDGROVE BRIDGE, 1923. This bridge gave access to land cut off between the River Thames and the canal. The bridge was demolished because modern farm machinery was unable to negotiate the humped back and narrow waist of the arch of the bridge. Demolition merely collapsed the bridge into the canal bed where it served as hardcore.

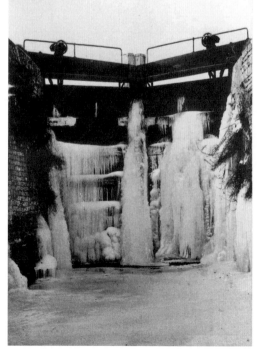

DUDGROVE DOUBLE LOCK, 1907. This was the only double lock on the canal and it had a properly built upper chamber, but a poorly built lower chamber. The canal had been built to the upper chamber before the final decision had been made as to where to join the River Thames. Pressure was exerted to finish the canal quickly and therefore the poorly built lower chamber was added to lower the canal to join the Thames at Inglesham corner, where the River Coin also joined, creating a deeper channel in the Thames. Frost was one of the great enemies of canals and could stop navigation for many weeks, as witness here the middle gates of the double lock.

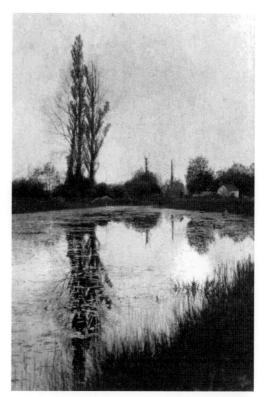

INGLESHAM POUND, *c.* 1910. Originally the terminus of the canal was envisaged as being at the Inglesham junction with the Thames, and in anticipation of the trade here, a large turning pound was made just above the last lock. In effect this did not happen and the pound was little used.

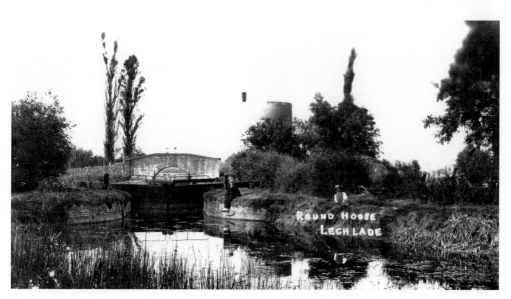

INGLESHAM LOCK AND ROUND HOUSE, *c.* 1900. This was the last lock on the canal and through the bridge the canal joined the River Thames on the bend just above its confluence with the River Coin. Note the reeds growing in the canal. These were cut and taken down the river for the chair-making industry (see page 154).

JOHN RAWLINGS, INGLESHAM
LENGTHSMAN, *c.* 1915. Seen here
standing on the towpath by the side of the
small warehouse, with the towpath bridge
over the river behind him.

JOHN RAWLINGS, INGLESHAM
LOCK-KEEPER, *c.* 1925. Now an old
man, he was the last lock-keeper at
Inglesham. The canal was only two years
from abandonment and he had probably
been allowed to continue living in the
round house as most of the eastern section
workforce had been discharged some years
previously.

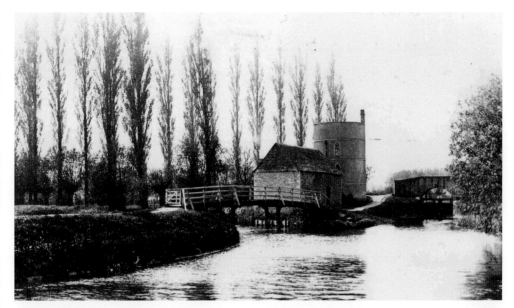

INGLESHAM JUNCTION, *c.* 1905. The bridge with the lock behind it, the round house, the small warehouse and the towpath bridge over the river. The River Coin flows into the Thames from the right and consequently deepens the channel at this point, making it more suitable for canal traffic.

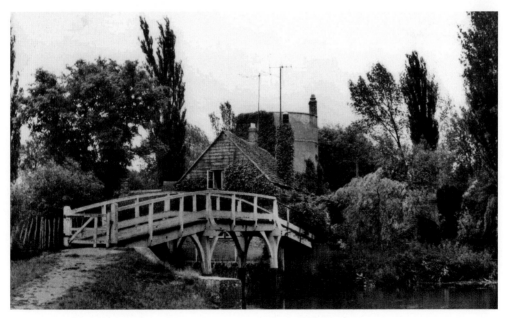

INGLESHAM JUNCTION, 1948. This scene is quite different from the previous one as the bridge and lock have disappeared in the trees and the small warehouse has been altered to private accommodation since 1929. There is also a replacement bridge over the Thames, which has now been removed and another one erected further down stream.

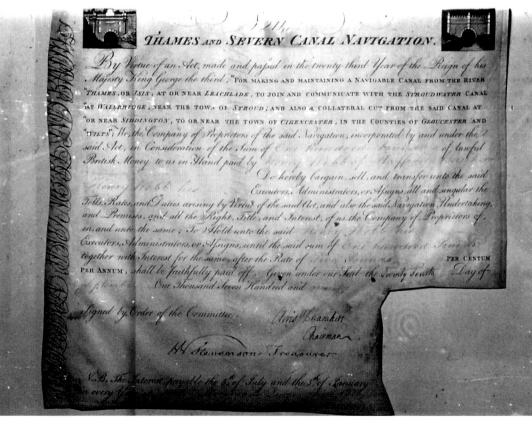

THAMES & SEVERN CANAL NAVIGATION SHARE CERTIFICATE, 1790. This share certificate is No. 214 for £100 to Mr Henry Webb of Stafford, a banker. Regrettably it has lost the company seal but is a very interesting document.

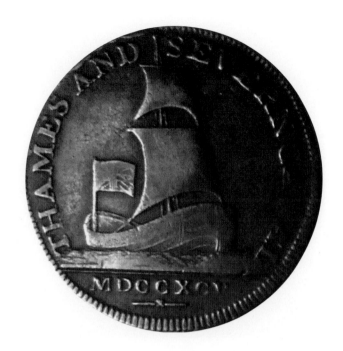

COMPANY HALFPENNY
TOKEN, 1795, Obverse.

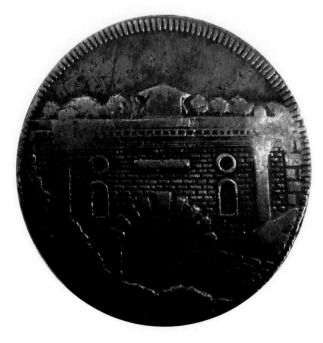

COMPANY HALFPENNY
TOKEN, 1795, Reverse. In
common with many other
companies at this time the canal
company had halfpenny tokens
struck to help ease the small
change coinage shortage at the
end of the eighteenth century. The
token had a Severn trow on the
obverse, the Coates portal on the
reverse and around the edge was
stamped 'Payable at Brimscombe
Port'.

THAMES & SEVERN CANAL COMPANY 'LOGO', on bricks.

THAMES & SEVERN CANAL COMPANY 'LOGO', on iron. Being rightfully proud of its canal, the company used a 'Logo' which was stamped on bricks and ironwork.

MILESTONE; the free-standing one by Bourne Bridge.

MILESTONE; the built-in one by Smerrill Aqueduct.

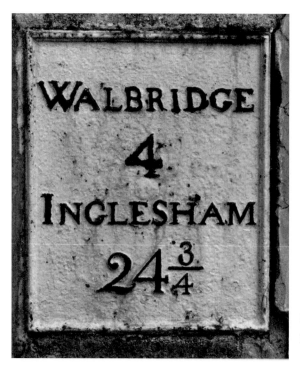

MILESTONE; the painted mileage plate at Chalford Chapel Lock site.

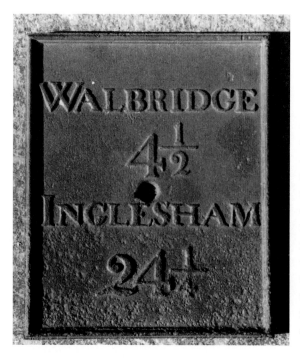

MILESTONE; the mileage plate from near Clowes Lock now in Stroud Museum. The canal had milestones showing the half miles and whole miles from Wallbridge and the intermediate quarter miles and three-quarter miles from Inglesham. The stones were freestanding when they had rounded tops or they were built into the towpath wall when they were square-topped. The mileage plate was of cast iron and fixed to the stone by an iron dowel set in lead.

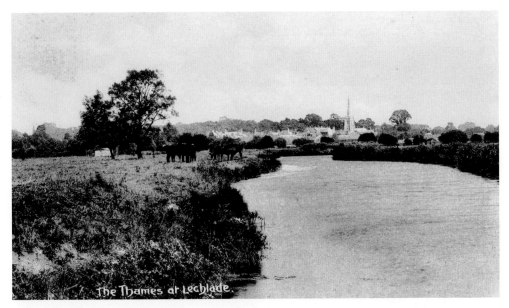

THE THAMES AT LECHLADE, *c.* 1910. This picture represents the view the bargees would have had as they came off the canal out of Inglesham Lock and onto the River Thames as they approached Lechlade. The towpath was on the right-hand bank of the river.

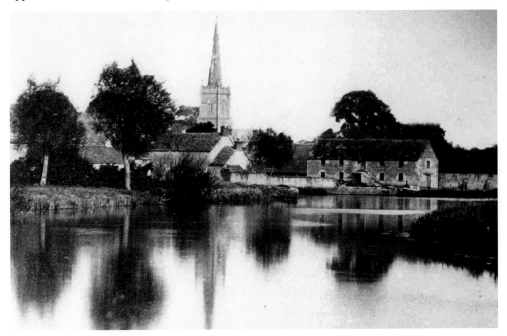

APPROACHING PARKEND WHARF, LECHLADE, *c.* 1900. The canal company soon realised that Inglesham Wharf was unsuitable as its terminus and bought Parkend Wharf at Lechlade in 1813. It was already an established trading wharf on the river and made an excellent base for the eastern end of the canal operations.

Lechlade Wharf
Feb 13th 1886

Dear Sir

In reply to your favour of this morning, I can do with a cargo of Smiths Coal, as much as you can bring along the canal in one boat. Let it be of good quality & do cheap as you possibly can put it. I have been offered Smiths Coal by Rail very cheap.

Yours truly
Matthew Hicks

CANAL AGENT'S LETTER, 1886. This letter is from Matthew Hicks at Lechlade Wharf to Mr J. Smart of Chalford requesting a barge-load of coal. Note the mention of railway competition.

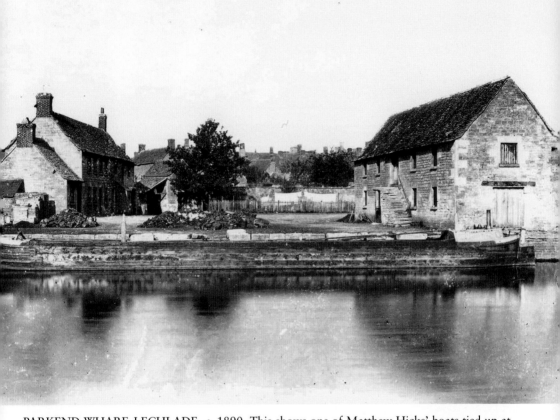

PARKEND WHARF, LECHLADE, *c.* 1890. This shows one of Matthew Hicks' boats tied up at the wharf. To the right is the general warehouse and to the left is the agent's house, office and salt store, whilst on the open wharf there are piles of coal. Salt, timber, reeds, cheese and grain were also extensively traded from this wharf.

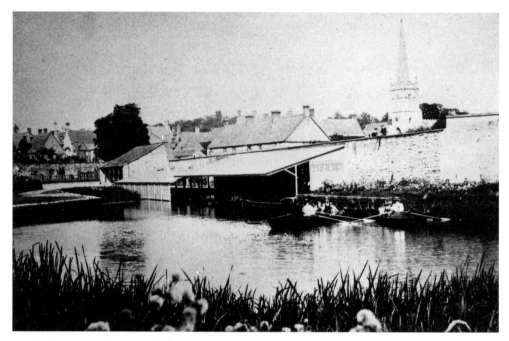

PARKEND WHARF, LECHLADE, *c.* 1900. This shows the dock alongside the road with the cart sheds in the background where there was one of the entrances into the wharf. Even in Victorian times the river was used for pleasure-boating, and with the decreasing canal and river traffic, this dock was increasingly used for the hiring of rowing boats.

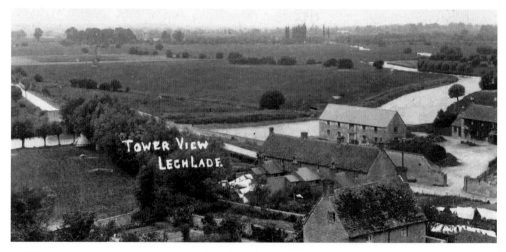

VIEW FROM LECHLADE CHURCH TOWER, *c.* 1900. The positions of the wharf, river, Halfpenny Bridge and the canal are all easily seen in this view. The canal enters the river in the centre distance by the clump of poplar trees. On the wharf are bundles of reeds that have been gathered mainly from the canal, ready to be sent down the river for the chair industry. At this time it is most likely that the coal on the wharf had been brought from the Midlands down the Oxford Canal and up the river.

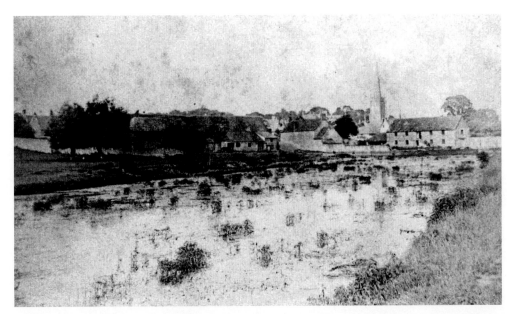

WEED GROWTH IN THE RIVER THAMES, *c.* 1880. This picture shows how easily the navigation of the river above Lechlade, and consequently access to the canal, could be impeded due to lack of dredging by the Thames Conservancy. Large clumps of weeds have grown up in the shallow waters just above the wharf.

FROZEN RIVER THAMES, 1963. Adverse weather in the winter could also stop navigation on the river, as shown here by thick ice. Ice boats could usually manage to break ice up to about three inches thick, but it was a losing battle for many weeks.

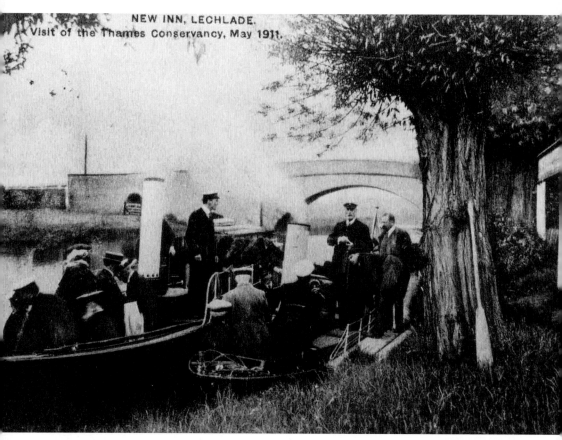

NEW INN, LECHLADE.
Visit of the Thames Conservancy, May 1911.

VISIT OF THE THAMES CONSERVANCY, May 1911. Since its establishment in 1866, the Thames Conservancy made an annual inspection of the state of the river. Its members are seen here arriving in their steamlaunches at the landing stage of the New Inn at Lechlade where they probably stayed overnight. It was not until 1892 that this governing body actually put in hand works to make the river fully navigable by making purchases of locks and weirs and abolishing the flash lock practices. However, most of these improvements came too late to help canal traffic.

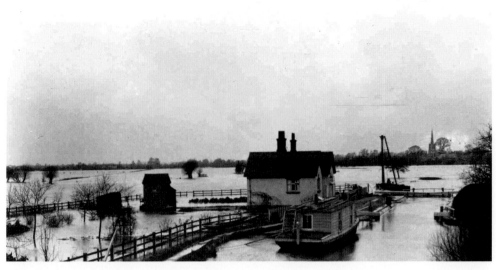

FLOODED RIVER THAMES, 1924. Floods could also stop navigation of the river as the channel disappeared in a sea of water as shown here by the total flooding of the flat land to either side of the river. St John's Lock lies just in front of the boat with water up to the tops of the lock gates.

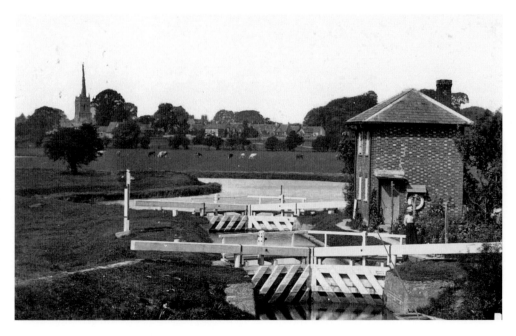

ST JOHN'S LOCK, LECHLADE, 1898. This was the first lock on the river and shown here is the original lock-keeper's house on the 'island' between the lock and the weir.

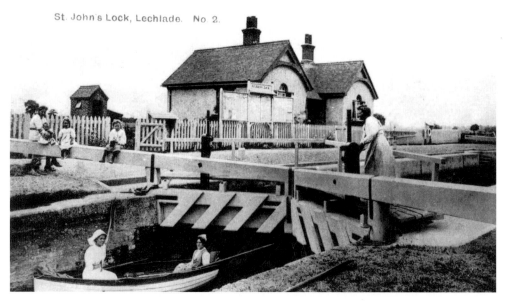

ST JOHN'S LOCK, LECHLADE, *c.* 1905. A new bungalow for the lock-keeper was built on the opposite side of the lock as shown in this Edwardian view.

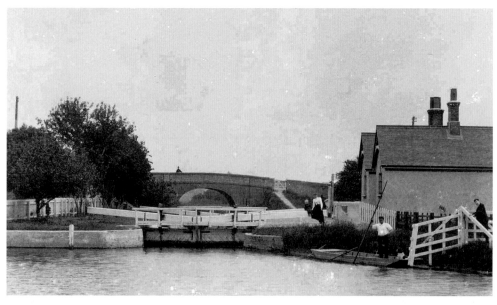

ST JOHN'S LOCK AND BRIDGE, LECHLADE, *c.* 1910. This view looking down stream shows the lock and bridge but the weir is off to the left behind the trees on the other side of the bridge.

THE TROUT INN, 1907. Beyond St John's Lock just off the road over the bridge stands the Trout Inn. A building has stood here since *c.* 1200. Mr J. Bowyer, the landlord, stands outside and the pub sold Bowlys' Entire beer supplied by the Stratton St Margaret brewery. The four counties of Gloucestershire, Oxfordshire, Berkshire and Wiltshire used to meet on the bridge until the county boundary of Oxfordshire was extended to the south in 1974.

ACKNOWLEDGEMENTS

We have endeavoured to acknowledge the original owners or lenders of the photographs which we have used, and our grateful thanks go to those organisations and individuals listed below for their help, which has enabled us to compile this selection.

Gloucestershire Records Office Photographs are reproduced with their kind permission; Canal Card Collectors Circle; Cirencester Historical and Archaeological Society; Corinium Museum, Cirencester; Cricklade Museum; Oxfordshire County Libraries; South Cerney Local History Group.

Dr R. Allen • Mrs E. Bignell • Mrs J. Blanshard • R. Bradley • Mrs M. Bray • B. Carter
R. Clarke • Mrs Cottrell • Mrs Dangerfield • Mrs G. Davis • W. Davis • S. Flatman • J. Foet
P. Gardiner • J. Garner • H. Gifford • Mrs C. Gleed • M. Goodenough • P. Griffiths
L. Grimmett • F. Hammond • E. Harper • Dr C. Hart • B. Hillsdon • J. Histed • O. Hunt
M. Lambert • Miss Leach • F. Lloyd • D. McDougall • Mrs J. Martin • S. Matthews
W. Merrett • M. Mills • Miss M. Niblett • L. Padin • M. Riddihough • B. Rushby • H. Sharpe
R. Simpson • R. Smart • J. Stayte • Mrs Steele • J. Stephens • Mrs M. Stephens • P. Sturm
Mrs J. Tanner • Mrs Thurston • H. Trigg • R. Turner • D. Viner • Miss Wallis
W. D. Young